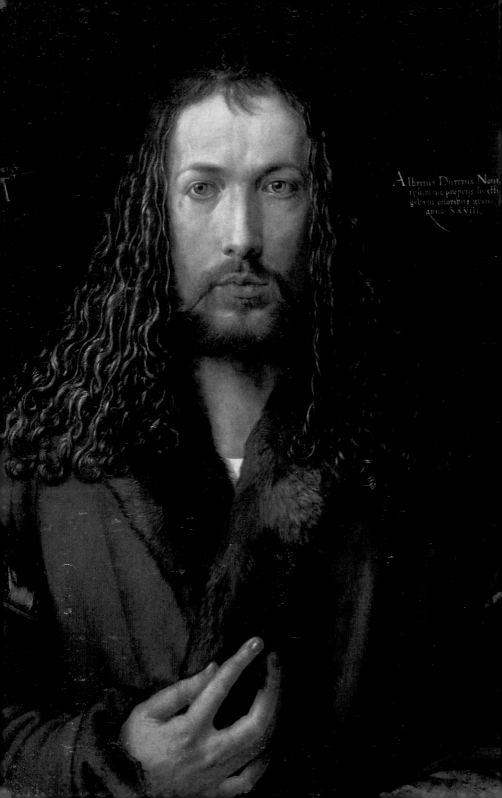

ArtBook
Dürer

DORLING KINDERSLEY

London • New York • Sydney • Moscow

Visit us on the World Wide Web at http://www.dk.com

Contents

How to use
this book

This series presents both
the life and works of each
artist within the cultural,
social, and political context
of their time. To make the
books easy to consult, they
are divided into three areas
which are identifiable by
side bands of different
colors: yellow for the pages
devoted to the life and
works of the artist, light
blue for the historical and
cultural background, and
pink for the analysis of
major works. Each spread
focuses on a specific theme,
with an introductory text
and several annotated
illustrations. The index
section is also illustrated
and gives background
information on key figures
and the location of the
artist's works.

■ On page 2: Dürer, *Self-
portrait in a Fur-Collared
Robe,* 1500, Alte
Pinakothek, Munich.

1471-1499

1500-1507

1508-1519 **1520-1528** **Index**

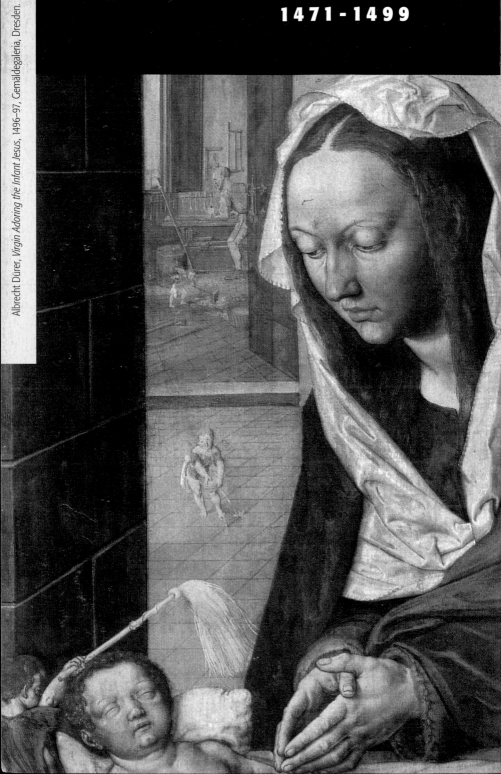

Albrecht Dürer, *Virgin Adoring the Infant Jesus*, 1496–97, Gemäldegaleria, Dresden.

A family of emigrants

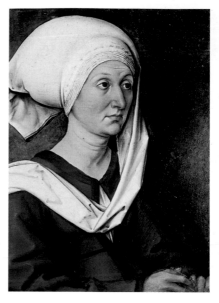

Albrecht Dürer was one of the greatest of all German artists and a principal thinker of the Renaissance. His art dominated the European cultural scene during the first decades of the 16th century. Always at the forefront of intellectual debate and consorting with artists and thinkers, princes and emperors, he was a key player in the major historical events of his time. We know a great deal about him, thanks to the ample documentation of the day and to the master's own diaries and notes. His father, also named Albrecht, was descended from a family of Hungarian goldsmiths. In 1455 Albrecht the Elder moved to Nuremberg, where he adopted the surname Dürer and found employment in the workshop of the gold- and silversmith Hyeronimus Holper. In 1467, aged 40, he married Holper's daughter Barbara. After more than 10 years he became more or less established in one of the most thriving cities in Europe and was in the very business which was at the center of the economy and exports: the working of prized metals to make precious objects or scientific instruments. In 1468 Albrecht the Elder was granted membership of the goldsmiths' guild and opened his own workshop. On May 21, 1471 his son Albrecht was born, the third of 18 children.

■ Dürer, *Portrait of his Mother Barbara Holper*, 1490, Schlossmuseum, Weimar. This portrait of his mother is probably one of Dürer's earliest paintings, although its attribution is doubtful.

■ Dürer, *View of Nuremberg from the West*, 1497, formerly Kunsthalle, Bremen. This splendid watercolor shows Dürer's feeling for landscape.

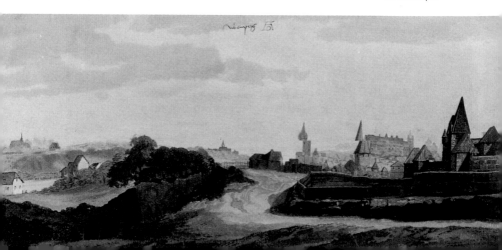

A child prodigy

As the inscription tells us, the silverpoint self-portrait below was executed in 1484 (Albertina, Vienna). The childish face of the 13-year-old artist is framed by long hair. He was at that time in the workshop of his father, who wanted him to train as a goldsmith: the young Albrecht, however, was most interested in drawing, a useful skill in goldwork and one in which his father was also competent. This drawing also marks the beginning of Dürer's insistent analysis into his own appearance, through a series of self-portraits that enable us to follow the development of his features and his psyche at every stage of his life.

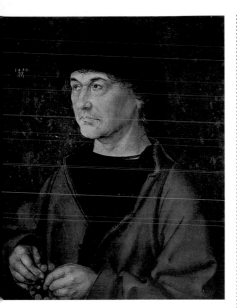

■ Dürer, *Portrait of Dürer's Father*, 1490, Galleria degli Uffizi, Florence. This intense portrait illustrates Dürer's precocious talent: at the young age of 18, he revealed skills which projected him at once to the heights of German art. Sealed and dated at the top and behind the canvas, the painting marks the end of his apprenticeship and the eve of his first long study trip. It is also the first example of Dürer's skill as a portrait painter, able to read the features of his sitters and evoke their personality. The face and hands of the artist's father suggest patience, tranquillity, and manual skill. Behind are the crests of the Holper and Dürer families.

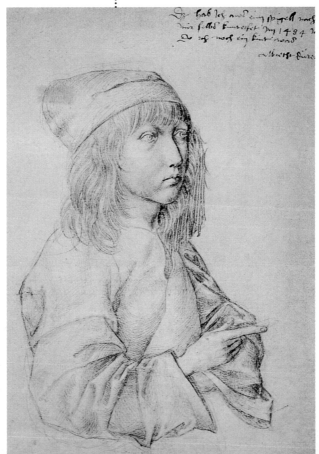

9

Nuremberg's "golden" age

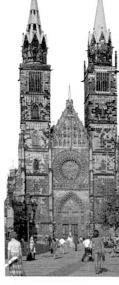

Between the 15th and the 16th century Nuremberg, the capital of Franconia, was, together with Cologne and Augsburg, the most densely populated and wealthiest German city: after the Diet of Worms (1521) it rose to become the economic capital of Germany. Among its 50,000 inhabitants, protected by a splendid circle of walls and a proud castle, a conspicuous class of cultured and moneyed merchants flourished, promoters of a lively cultural and artistic life. Imperial privileges and the traditional working of precious metals widened Nuremberg's commercial confines throughout Europe, from Cracow to Lisbon, from Venice to Lyons. Bomb damage in World War II has partly wiped out the urban fabric of the city, but the main Gothic monuments and its grand collection of works of art still convey a sense of spectacular richness. Nuremberg was one of the first cities to have printing presses and laboratories producing scientific instruments. Humanistic studies were supported by amply stocked libraries. In Dürer's time Nuremberg was a cosmopolitan city, where it was easy to meet literary figures, mathematicians, geographers, theologians, artists, and merchants.

■ The facade of the St Lorenzkirche, Nuremberg's main church: it housed the school which Dürer attended between the ages of 10 and 12, before beginning his apprenticeship in his father's workshop.

■ *View of Nuremberg* printed by Hartmann Schedel, 1493. The imposing castle watches over the city. The spires of the St Lorenzkirche and St Sebalduskirche are visible on the left.

■ The sculptor Adam Krafft left his own self-portrait at the base of the tabernacle in the St Lorenzkirche: executed between 1493 and 1496, the tabernacle is a masterpiece of high Gothic, a carved tower more than 20 meters (650 feet) high, which looks like a piece of stone embroidery.

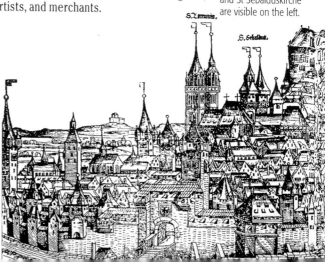

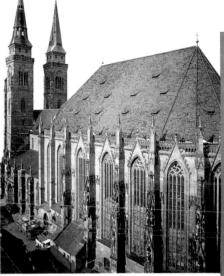

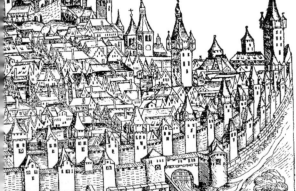

■ The apsidal and right-hand side of the St Sebalduskirche, the beautiful Gothic church in which Dürer was baptized. His godfather was Anton Koberger, the city's foremost printer and publisher, a prophetic choice given Dürer's later exceptional work as an engraver. Right, the reliquary-tomb of St Sebaldus, a goldwork masterpiece.

Goldwork, a leading art

Almost 80 centimeters (30 inches) high and weighing about six kilograms (13 pounds), this silver-gilt ship (1503, Germanisches Nationalmuseum, Nuremberg) symbolizes Nuremberg's role as the flagship of gold- and silverwork during the Renaissance. Exported throughout Europe, Nuremberg's silver was highly prized for both its artistic quality and fine technique. Clocks, musical instruments, nautical and astronomical equipment were all sought after. From the early 15th century until the eve of the 17th century, Nuremberg was one of the most advanced European centers for goldwork; Augsburg took over its supremacy as silver capital toward the end of the 16th century.

Dürer the apprentice: from goldwork to painting

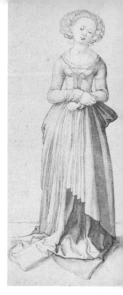

Together with some of his many siblings (none of whom would display any outstanding artistic ability), Albrecht Dürer was apprenticed by his father in the family's workshop. His talent soon revealed itself. On November 30, 1486, Albrecht the Elder decided with some regret but also great foresight, to release his most gifted son, now aged 15, and to apprentice him to the painter Michael Wolgemut. The artist, one of the most brilliant in Nuremberg, lived near the Dürers' house (in 1475 the family had moved to a spacious and elegant dwelling). Dürer spent three years with Wolgemut and some interesting drawings, still executed in a late-Gothic manner, date from this period. Following in his master's footsteps, the young Dürer most likely also worked on some woodcuts at this time, taking part in collective decoration and illustration projects for the main books that were printed in Nuremberg; though the attribution of these very early woodcuts is not conclusive. No painting from his early teenage years is recorded and the *Portrait of his Father Albrecht the Elder* (1490) in the Galleria degli Uffizi remains Dürer's first documented masterpiece.

■ Dürer, *Nuremberg Maiden Dressed for Church*, British Museum, London. Executed during his apprenticeship with Wolgemut, this expresses the late-Gothic elegance of his first known works.

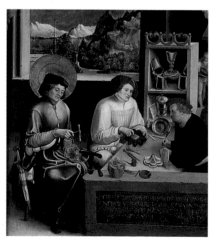

■ Niklas Manuel Deutsch, *St Eligius in the Workshop*, Kunstmuseum, Berne. This German goldsmith's workshop gives an idea of Dürer the Elder's own workshop, and of the instruments and working methods he would have used.

■ Dürer, *Gothic Table Fountain*, British Museum, London. Dürer never forgot his training as a goldsmith.

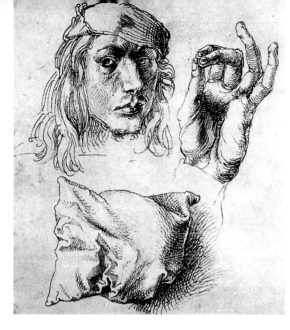

■ Dürer, *Self-portrait with Studies of a Hand and a Cushion*, Lehman Collection, New York. The draughtsmanship of the young Dürer, now aged 20, becomes incisive and probing, mindful of every detail.

■ Dürer, *Portrait of the Painter Michael Wolgemut*, 1516, Germanisches Nationalmuseum, Nuremberg. Thirty years after being apprenticed to him, Dürer dedicated this portrait to Wolgemut, still addressing him as "master", as can be seen from the inscription at the top of the painting.

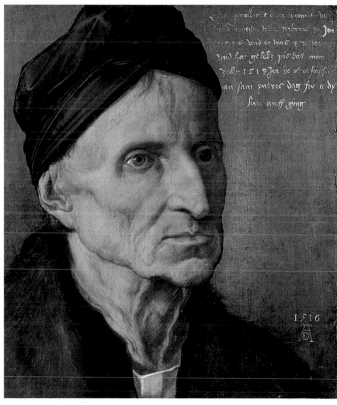

German art at the end of the 15th century

BACKGROUND

Nuremberg and Franconia occupied a central position in the development of German painting in the second half of the 15th century. German art, although still entrenched in the Gothic style, was at this time searching for a more wide-ranging artistic expression, thanks to its sensitivity toward landscape and its ever-increasing cultural links with northern Italy and Flanders. The turning-point in this process was marked by Dürer's work, although a certain dynamism in the painting of central-southern Germany could already be discerned during the last quarter of the 15th century. The most interesting works from this period were large altarpieces, often executed by means of a combination of parts sculpted in wood and painted sections. An unsurpassed master of this technique was Michael Pacher, who was an excellent painter and sculptor, able to transcribe the humanistic training he had received in Padua into a late-Gothic key. The greatest artist in Franconia was the sculptor Tilman Riemenschneider, who produced altarpieces in wood.

■ Master of the House Book, *Two Lovers*, 1480–85, Germanisches Nationalmuseum, Nuremberg. The unusual subject (halfway between a double portrait and genre painting) is painted elegantly under a scroll.

■ Konrad Witz, *The Miraculous Draught of Fishes*, c.1450, Musée d'Art et d'Histoire, Geneva. Set in Lake Constance, this is a masterpiece of 15th-century German art.

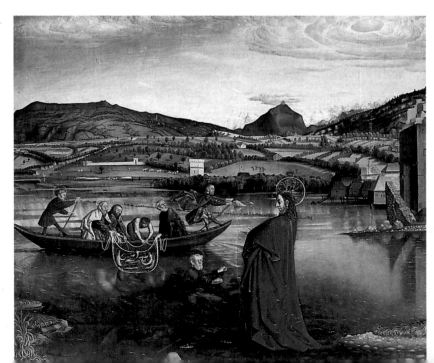

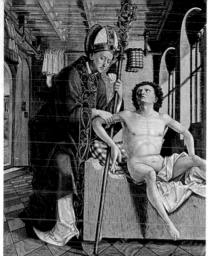

■ Michael Pacher,
*St Wolfgang Healing a
Sick Man*, c.1480, Alte
Pinakothek, Munich.
The deep perspective
and the classical
anatomy of the naked
man reveal the link
with Italian humanism.

■ Master of the Altar
of St Augustine, *St Luke
Painting the Virgin*,
c.1480, Germanisches
Nationalmuseum,
Nuremberg. This work
expresses the refined
artistic climate
of Nuremberg.

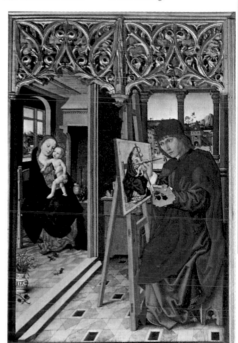

The triumph of wood

The most impressive German art form
at the end of the 15th century is the
wooden altarpiece. Most important
among these are the masterpieces
by Tilman Riemenschneider, such as
the *Holy Blood* altarpiece, in the
church of St James at Rothemburg
(c.1490). Perfectly preserved, this
grandiose work appears as a carved
structure, with spires and sculptures
that are full of pathos: the central
panel, which simulates a Gothic room
with arched windows, shows an
episode from *The Last Supper*.

A journey through early Renaissance art

At the end of his apprenticeship with Michael Wolgenut, the 19-year-old Dürer set off on a long study trip, which broadened his cultural vision into a wider European perspective: he was away from Nuremberg from April 1490 until May 1494. The details of his itinerary are not known and the controversy surrounding a visit to the Low Countries remains unresolved. Having journeyed through Bavaria, with stops at Nordlingen, Ulm, and Constance, Dürer spent some time in Basle, where he was able to admire the works of Konrad Witz. Following the course of the Rhine, he then moved on to Colmar, in Alsace, staying with the sons of the painter Martin Schongauer, studying his painting and engravings with interest. In Strasbourg he met the artist Hans Baldung Grien, with whom he forged a lasting friendship. During this time, Dürer earned his living producing drawings and engravings; he took part in collective book illustration projects (such as *Ship of Fools* by Sebastian Brant), but his main source of income, as in his subsequent journey to Italy, was the selling of prints, by himself and others. Dürer had sensed the economic potential of woodcuts.

■ Hans Holbein the Elder, *Madonna and Child*, Kunstmuseum, Basle. Head of a thriving workshop, Hans Holbein the Elder was a central figure in German art, going beyond the late-Gothic tradition to produce works which display a new stylistic clarity.

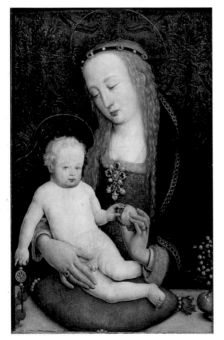

■ The Gothic spires of Basle cathedral , in red limestone, overlooking the river Rhine.

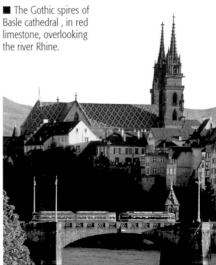

■ Two 17th-century engravings illustrating typical parts of old Strasbourg: the market place and the fortified bridges.

■ Anonymous German painter, *Diptych of Life and Death*, detail, c.1480, Germanisches Nationalmuseum, Nuremberg. This painting, dating from Dürer's time, shows the landscape of central Europe as it would have unfolded before the eyes of the young artist setting off on his journey.

■ Colmar: the old market place with the town hall and typical Alsatian houses.

■ Martin Schongauer, *Madonna of the Rose Garden*, 1473, Dominican Church, Colmar. One of the paintings Dürer admired most during his travels.

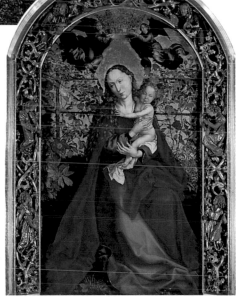

17

Family, friends, and character

From a very early age, Dürer displayed an idleness which is reflected in his self-portraits and numerous writings: a sophisticated and very charming man, always open to new experiences, journeys, and acquaintances, intensely religious, hostile to all excess, witty and not above risqué remarks, he was soon aware of his own greatness. Fastidious about the slightest detail concerning his person, his clothing, and his hair, Dürer was conscious of his unsettling good looks, made all the more attractive by a vaguely Oriental element and by the magnetism of his gaze. Although he was full of charisma, his family life nevertheless was a quiet one. In 1524 the artist published a *Family Chronicle*, thanks to which we know many intimate details of his life. Dürer married at the age of 23, on July 14, 1494. His wife, Agnes Frey, was the daughter of a well-known Nuremberg goldsmith. The couple lived in the Dürer family home, together with his siblings (no fewer than 17). Only after 15 years of marriage did they acquire their own home. Dürer was introduced into the intellectual life of Nuremberg and would later take an active interest in civic administration and religious debate. Thanks to his moderation and appealing personality, he had many friends in high circles: the highly cultured humanist Willibald Pirckheimer was almost a brother to him.

■ Dürer, *Agnes Frey Dürer ("Mein Agnes")*, Albertina, Vienna. This hasty drawing, a rough sketch of just a few lines, is Dürer's first portrait of his wife, and captures her unawares in a moment of quiet reflection.

■ The Dürer family crest, an open door with a double shutter, with the AD monogram.

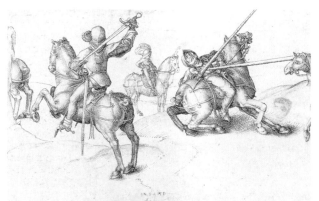

■ Dürer, *Light Horsemen Fighting*, British Museum, London. A youthful drawing, still inspired by imaginary Gothic chivalry. The world of heroes and fables lingered in his mind, even when to tried to work out a geometric canon of beauty.

Peculiarities of nature

The *image* of the *Monstrous Sow of Landser* in one of Dürer's earliest engravings illustrates his almost morbid interest in any unusual manifestation of nature. Phenomena such as this were usually interpreted as obscure premonitions, unleashing fear and superstition. For the young Dürer, however, the birth of a freak creature or the possibility of viewing exotic animals were opportunities to study the quirks in the beauty of the universe.

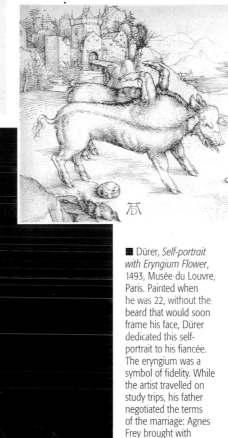

■ Dürer, *Self-portrait with Eryngium Flower*, 1493, Musée du Louvre, Paris. Painted when he was 22, without the beard that would soon frame his face, Dürer dedicated this self-portrait to his fiancée. The eryngium was a symbol of fidelity. While the artist travelled on study trips, his father negotiated the terms of the marriage: Agnes Frey brought with her a dowry of 200 gold florins.

Giovanni Bellini and Giorgione

\mathbf{T}he beautiful circle of walls protecting Nuremberg was too restricting for an international spirit like Dürer's. In the autumn of 1494 the 23-year-old painter set off on a new study trip to Italy which would last until the spring of 1495, taking in Padua, Mantua, and Venice. It was the young German artist's first direct contact with Italian humanist culture. Crossing the Alps was an exciting experience for him: Dürer produced moving pictures of the Alpine landscape in a series of extraordinary watercolors. Between Lombardy and the Veneto he visited the main centers of humanism and the workshops of artists such as Mantegna and Bellini. Dürer's first journey to Italy was a fundamental stage in his development; besides his passion for Italian art and an enduring love for the country's good taste and climate, the master also became interested in how best to depict space and the proportions of the human body within the purest spirit of humanism. Northern Italian artistic culture, particularly that of the Veneto, was in turn keen to embrace the novelties introduced from the German region. Dürer went to Italy for the first time as a humble young man needing to complete his artistic training but it must not be forgotten that this early visit also formed the basis for the subsequent exchange of suggestions and ideas between Dürer and Venice.

■ Giovanni Bellini, *Madonna and Child*, 1480–90, Accademia Carrara, Bergamo. Dürer greatly admired Bellini's balance between the figures and the landscape, the gentle light, and the interplay between drawing and color .

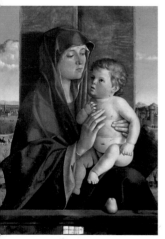

■ Giorgione, *Adoration of the Magi*, c.1504, National Gallery, London.

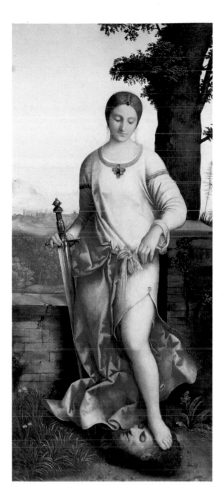

■ Giorgione, *Judith*, 1506. Hermitage State Museum, St Petersburg. Despite the morbidity of the atmosphere, the woman (a large figure, unusual in Giorgione) recalls northern engravings, particularly in the refined drapery.

■ Giovanni Bellini, *Lamentation over Christ*, 1474, Pinacoteca Vaticana, Vatican City. Together with the serene monumentality of the figures, Bellini displays a clarity of drawing in the works he produced before 1500 which Dürer would undoubtedly have appreciated.

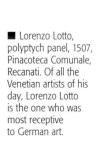

■ Lorenzo Lotto, polyptych panel, 1507, Pinacoteca Comunale, Recanati. Of all the Venetian artists of his day, Lorenzo Lotto is the one who was most receptive to German art.

Early engravings and the humanist call

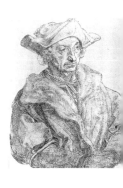

Dürer produced engravings through-
out his career, an activity he may have begun through economic
necessity. These works make him one of the foremost artists in
the history of old prints. Like Rembrandt and Goya, Dürer
considered engraving to be an art in itself, not subordinate to

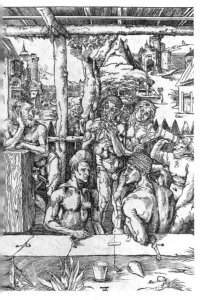

painting, and he pioneered a variety
of new techniques and themes.
The engravings (which also owe
their quality to the excellent
printing presses in Nuremberg)
were also the basis for the
considerable diffusion of Dürer's
art: series such as the *Life of the
Virgin*, the *Large Passion* (both on
wood) and the *Small Passion*
(on copper) were studied by
painters from different countries,
influencing the development of
Renaissance art in Europe. Dürer
invested his prints with a whole
universe of study and knowledge.
An investigation into the human
body prevails, however, with many
nudes, which led to a wider analysis
of anatomical proportions.

■ Dürer, *The Bath
House*, 1496. One of the
oldest large woodcuts,
this shows a few figures
in a rudimentary bathing
establishment. Dürer
also made a preliminary
sketch for a companion
print, *The Women's
Bath*, which was
never cut.

■ Dürer, *The
Temptation of the
Idler*, or, *The Dream
of the Doctor*, 1497–98.
This allegorical print
includes one of the
first full-length nudes
produced by the artist,
who was at this time
in search of a formal
aesthetic canon.
The sleeping figure
may be his friend
Willibald Pirckheimer.

■ Dürer, *Portrait of the Writer Sebastian Brant*, 1520. Executed in his later years, during Dürer's journey to the Low Countries, this portrait is a tribute to the Dutch author of the widely-read *Ship of Fools*, a book which also inspired some works by Hieronymus Bosch.

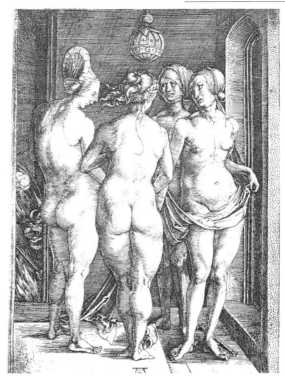

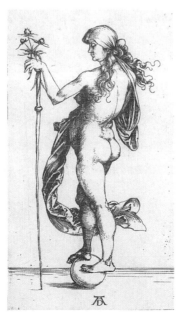

■ Dürer, *The Four Witches*, 1497. The influence of Italian art, particularly Mantegna, is very much in evidence in this work, especially in the way in which the figures face each other. The mysterious sphere above, inscribed with magic letters, hints at Dürer's feeling for the esoteric.

■ Dürer, *Fortune*, 1496. The figure of the naked woman, balancing precariously on a sphere, recurs a few years later in one of Dürer's most spectacular engravings, of which this can be regarded as a refined experiment.

The Four Horsemen of the Apocalypse

The *Four Horsemen of the Apocalypse* is one of
the 15 lithographs from the illustrated edition
of the *Apocalypse* of St John (1498), Dürer's
first major success.

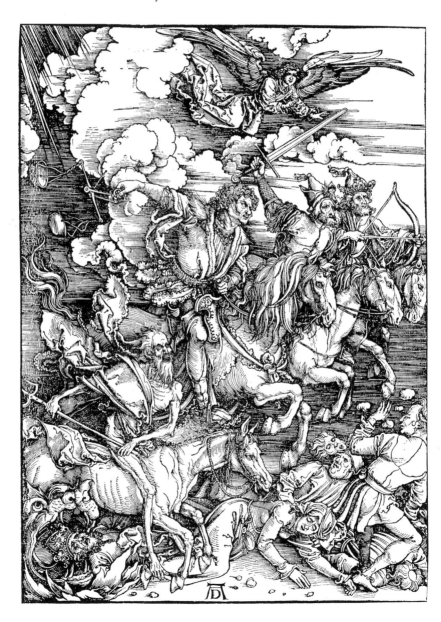

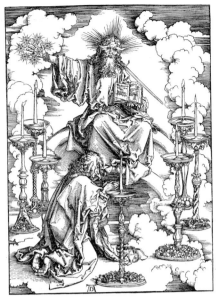

■ *The Vision of God the Father among the Candle-Holders* is one of the more metaphysical plates. Dürer succeeds in translating the evangelist's mystical evocations into visual images, while following his text to the smallest detail, such as the fiery countenance of the Lord, with a sword issuing from his mouth.

■ Dürer added the frontispiece, with *St John Inspired by the Virgin Mary*, at a later stage, for the 1511 edition.

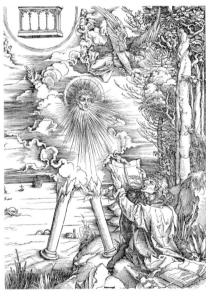

■ *St John Swallows the Book*. Dürer places divine apparitions in real-life landscapes, which may appear familiar to the observer. In this way the fantastic register is linked with the reader's own experience, enabling him to identify with St John, and the episodes from the *Apocalypse* are set in a personal context.

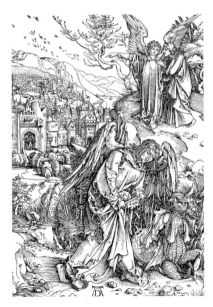

■ *The Angel Shows St John the Heavenly Jerusalem*. In the foreground an angel subjugates the devil. Behind him St John has climbed onto a hillock.

Dürer has given the evangelist the role of "narrator", relating the stories of the book in the first person, thus establishing a dialogue with the reader.

Frederick of Saxony, the first patron

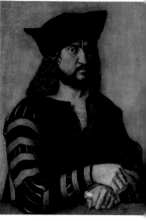

In 1496, during an official visit to Nuremberg, The Grand Elector Frederick of Saxony, known as Frederick the Wise, publicly professed his admiration for the 25-year-old Dürer and commissioned a portrait and a series of paintings destined for the castle and the Schlosskirche, the castle church in Wittenberg. This marked the beginning of a lasting patronage, as well as a mutual friendship between the artist and one of the most influential and powerful figures in German politics. The endorsement of Frederick the Wise provided a remarkable spur for the career of an artist who was still very young and practically just setting out. The works painted for the prince's residence and for the castle church at Wittenberg (where a few years later Luther would affix the 95 Theses of the Reformation) are today housed in various museums: two polyptyches, known as the *Jabach Altarpiece* and the *Polyptych of the Seven Sins* have been dismantled and it is difficult to reconstruct their original appearance. The *Labors of Hercules* cycle has also been split up. During the early years of the Reformation Frederick of Saxony sought to mediate between Catholics and Lutherans, favoring the convocation of the Diet of Augsburg, to which Dürer was also invited (see pages 84–85).

■ Dürer, *Portrait of Frederick the Wise*, 1496, Staatliche Museen, Berlin. This imposing and austere picture of the prince marked the beginning of a long association between the artist and his patron.

■ Dürer, *Frederick the Wise, Elector of Saxony,* 1524. This engraving, produced 28 years after the portrait which is now in Berlin, is evidence of the uninterrupted relationship between Dürer and his first great patron, who became one of the key figures in the Reformation for the support and protection he gave Luther.

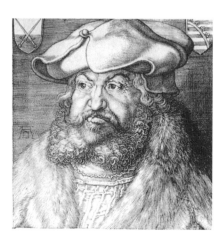

■ Dürer, *Job and his Wife*, 1503–04, Städelsches Institut, Frankfurt. Left-hand panel of the *Jabach Altarpiece*, formerly in the church at Wittenberg: the derision of Job is one of Dürer's first meditations on the theme of melancholy, as evidenced by the typical gesture of the head leaning on the hand.

■ Dürer, *Killing the Stymphalian Birds*, 1500, Germanisches Nationalmuseum, Nuremberg. This is Dürer's only mythological painting. Its classical context makes it a rare work within the German Renaissance.

■ Dürer, *Two Musicians*, 1503–04, Wallraf-Richartz Museum, Cologne. The right-hand panel of the *Jabach Altarpiece*. The tambourine player is a self-portrait of Dürer.

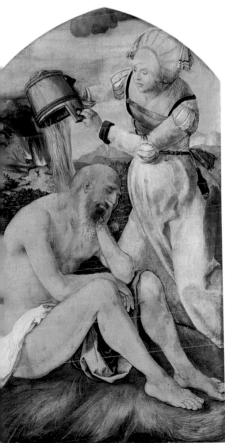

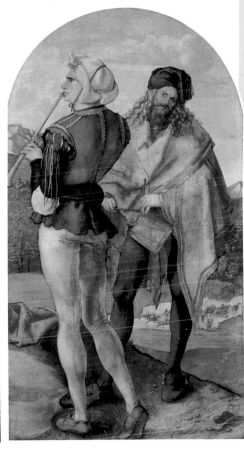

The portraits

Dürer was a universal artist, open to different themes, forms, and techniques and always striving toward progress in painting without restricting himself to the confines of a specialist output, as was the case with many other painters of the Renaissance and subsequent periods. Throughout his career, however, despite the grandiose range of his activities, he devoted particular attention to portraiture, becoming one of the form's most interesting interpreters of all time. Taking as his starting point the tradition of graphic accuracy, typical of northern European art, he had learnt from Wolgemut and during the course of his study trips, his paintings, drawings, and engravings soon reflected a quest for the inner world in all its tensions and passion, a search for the secret, deeper aspects of the psyche. Dürer's progress in this parallels that of Leonardo da Vinci and has strong affinities with the work of Titian who, as a very young man, met the German master during his second journey to Venice. Among Dürer's most impressive youthful portraits is that of Oswolt Krel (below right), a member of a wealthy German family: the troubled, neurotic personality, the flash of cruelty which clouds the expression of the depraved young man are set against the serene landscape, the extreme delicacy of his hands, and his refined clothes.

■ Dürer, *Oswolt Krel*, 1499, Alte Pinakothek, Munich. Set in the open air and flanked by two panels showing "savages" and the family's heraldic crests, this is one of Dürer's most consummate masterpieces in which he conveys the surly and tense psychology of a neurotic, violent, and obsessed young man.

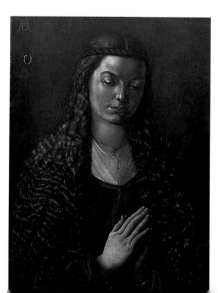

■ Dürer, *Katharina Fürlegerin,* 1497, Städelsches Institut, Frankfurt. Often regarded as a copy of a lost original, this portrait is one of Dürer's first and reveals his attention to the sitter's innermost feelings and thoughts, suggested through his skill as a draughtsman (an impeccable sketch of the hands exists) and by the effect produced by the light skimming over the figure.

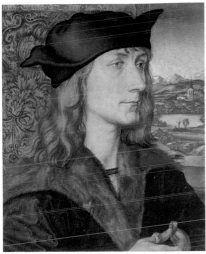

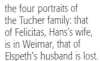

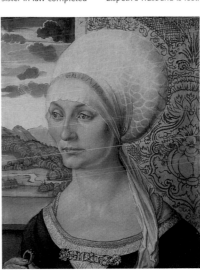

■ Dürer, *Elspeth Tucher*, 1499, Gemäldegalerie, Kassel. The portrait of Hans's sister-in-law completed the four portraits of the Tucher family: that of Felicitas, Hans's wife, is in Weimar, that of Elspeth's husband is lost.

■ Dürer, *Hans Tucher*, 1499, Schlossmuseum, Weimar. The subtle delicacy of the details is set off by the portrait's background, which is equally divided into a precious gold brocade and a landscape.

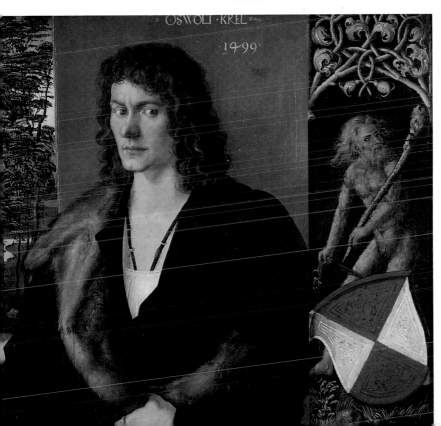

The Haller Madonna

Dating from c.1498 and housed in the National Gallery, Washington, D.C., *The Virgin in Half Length*, also known as the *Haller Madonna*, after the family who commissioned it, is the fruit of Dürer's observations during his first visit to Venice.

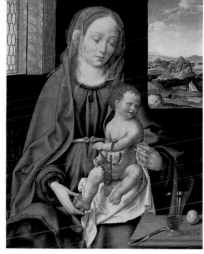

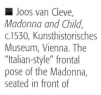

■ Joos van Cleve, *Madonna and Child*, c.1530, Kunsthistorisches Museum, Vienna. The "Italian-style" frontal pose of the Madonna, seated in front of a window opening out onto a landscape, persisted for a long time in northern European painting, due also to Dürer's authoritative example.

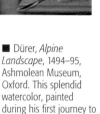

■ Dürer, *Lot and his Daughters fleeing from Sodom and Gomorrah*, c.1498, National Gallery, Washington, D.C. This painting is on the reverse of the *Haller Madonna*.

■ Dürer, *Alpine Landscape*, 1494–95, Ashmolean Museum, Oxford. This splendid watercolor, painted during his first journey to Italy, shows the Trentino area, near Lake Garda.

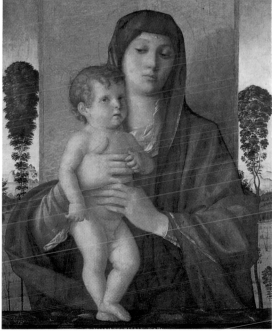

■ Giovanni Bellini, *The Madonna of the Saplings*, 1488, Gallerie dell'Accademia, Venice. The poetic Bellini, already elderly but always in the vanguard, was the artist Dürer most admired and followed during both his sojourns in Venice.

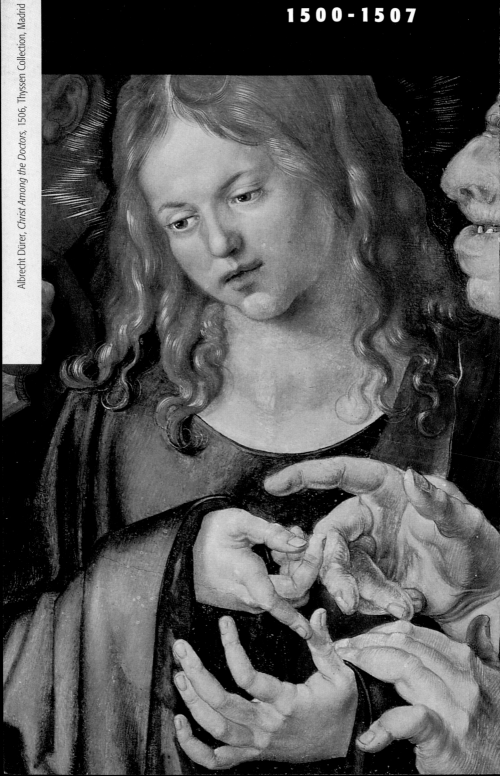

Albrecht Dürer, *Christ Among the Doctors*, 1506, Thyssen Collection, Madrid

Success
consolidates

Between narcissism and melancholy

Dürer's life is an intriguing blend of a highly successful career and public image and, on the other hand, a tormented inner self. At many stages in his life Dürer seemed to be balancing between a complacent awareness of his growing success and a deep, solitary depression. This ambiguity makes him an extremely interesting artist and enriches his work with a deep, psychologically introspective element. As a great, gifted painter, one of the central figures of his day, Dürer never lost touch with the reality of family and work, consciously living through the ambivalence between ambition and objective limits, a sense of history, and a domestic life that was not always entirely satisfactory (his marriage does not seem to have been particularly happy). Diaries, letters, and notes enable us to reconstruct the artist's daily life, in which enormous creative bursts alternate with minor preoccupations over small bills or other irritating economic encumbrances connected with housekeeping.

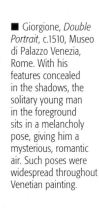

■ Dürer, *Self-portrait in the Nude*, Schlossmuseum, Weimar. In this drawing, dramatically truthful in its physical and psychological portrayal, Dürer takes on a nocturnal, gloomy appearance which is at the same time vigilant and almost Mephistophelian.

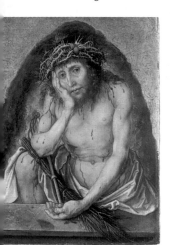

■ Dürer, *Christ with the Symbols of his Passion (Ecce Homo)*, 1498–99, Kunsthalle, Karlsruhe. The pose of downcast meditation, suggests a deep sense of introspection and grief.

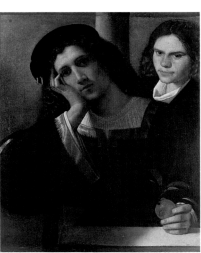

■ Giorgione, *Double Portrait*, c.1510, Museo di Palazzo Venezia, Rome. With his features concealed in the shadows, the solitary young man in the foreground sits in a melancholy pose, giving him a mysterious, romantic air. Such poses were widespread throughout Venetian painting.

■ Dürer, *Self-portrait At the Age of Twenty*, c.1491, University Library, Erlangen. From a very young age, Dürer suffered from melancholia, insomnia, violent headaches, and fits of depression which were resolved in artistic creativity.

■ Dürer, *Self-portrait with Landscape*, 1498, Museo del Prado, Madrid. Already enjoying some success, Dürer took pride in his appearance and in the prestige he had attained. He was no longer a craftsman, like his father, but an intellectual. The sidelong gaze gives the portrait a delicately aristocratic tone.

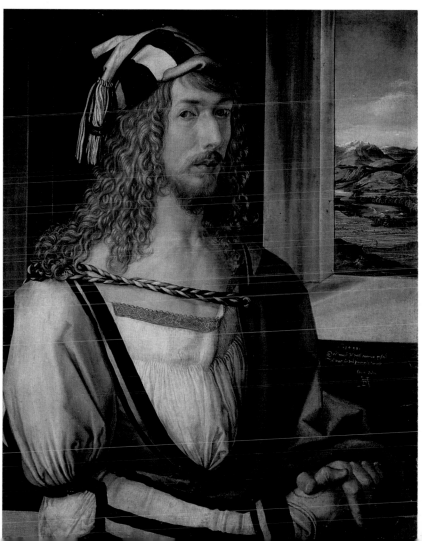

Veit Stoss and the early 16th century in Nuremberg

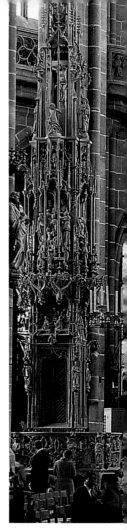

Working at the same time as Dürer was another prominent artist, the sculptor Veit Stoss. The presence of two such important figures within what was an ebullient cultural climate between the end of the 15th and the first three decades of the 16th century made the city in Franconia one of the main centres of European Renaissance art. Veit Stoss is one of the greatest exponents of sculpture in wood, most of all through his high altars, but his versatility was such that he also executed marble sculptures, engravings, and paintings. After a stay in Poland, which culminated in the large *Death of the Virgin* high altar in Cracow, he returned to Nuremberg in 1496. Without sacrificing his artistic imagination, and indeed celebrating it with unparalleled skill, he abandoned every last vestige of Gothic art in his carving to embrace a far-reaching monumentality. Like Dürer, Stoss also had strong links with Italy, particularly with Florence: two of his sculptures are to this day in the churches of the Annunziata and Ognissanti. In Nuremberg he produced a cycle of statues in stone for the choir of the St Sebalduskirche and numerous wood sculptures. Between 1517 and 1519 he created the *Annunciation*, suspended in the choir of the St. Lorenzkirche and, later, an *Altar of the Life of Mary* for the Carmelite church in Nuremberg, which is now in Bamberg.

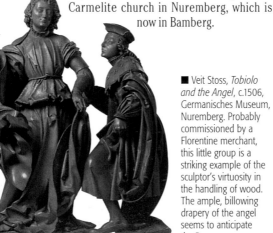

■ Veit Stoss, *Tobiolo and the Angel*, c.1506, Germanisches Museum, Nuremberg. Probably commissioned by a Florentine merchant, this little group is a striking example of the sculptor's virtuosity in the handling of wood. The ample, billowing drapery of the angel seems to anticipate the Baroque.

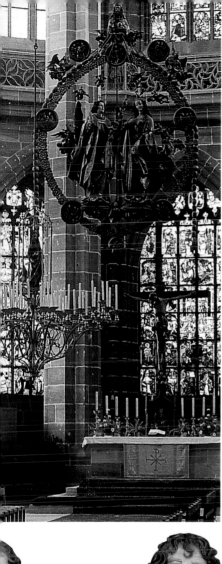

■ The splendid Gothic choir of the St. Lorenzkirche, Nuremberg, with its 15th-century stained-glass windows, Veit Stoss' *The Angel's Salutation* hanging in the centre and, on the left, the spire of the tabernacle by Adam Krafft.

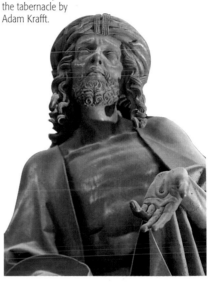

■ Veit Stoss, *Christ Crowned with Thorns*, detail, c.1507, St. Sebalduskirche, Nuremberg. Part of a group of stone statues produced by Stoss for this church, which was near Dürer's home.

■ Veit Stoss, *The Angel's Salutation*, 1517–19, St. Lorenzkirche, Nuremberg. The *Annunciation*, surrounded by a halo of angels and symbols, was Stoss' last gilded and colored wood group.

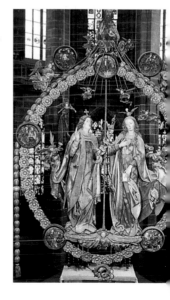

■ Veit Stoss, altar frontal of the *Death of the Virgin*, detail from the central group, 1478–89, St Mary's, Cracow. This gigantic altar, still in the late-Gothic tradition, was the sculptor's most ambitious work.

Stylistic development

■ Dürer, *Three Putti with Shield and Helmet*, c.1500. The influence of Mantegna and northern Italian humanism are evident in this engraving.

Around the year 1500, when he was nearly 30, Dürer's style took a new direction. Having built on the ideas he had derived from his long study trips, consolidated the success he had enjoyed with the *Apocalypse* by means of a prolific series of works, and now a key figure in Nuremberg's cultural life, Dürer developed a new and altogether original figurative model. The last residue of tradition (such as the minute donors who appear in the *Lamentation over Christ* and in the *Paumgartner Altar*) was about to disappear, engulfed by a powerful monumental vision: man, carefully in proportion and expressing feelings, had been studied as an individual subject, but from now on he was shown against the background of a natural world which the artist examined with keen scrutiny. Dürer viewed the relationship between the human figure and the environment surrounding it as a consummate search for harmony. The philosophical approach of his vision of the world is similar to that of Leonardo: in order to understand the great mysteries of the universe and to penetrate deep within the human "machine" both masters began with a meticulous, patient, driven enquiry into the smallest detail.

■ Dürer, *Portrait of a Young Man*, 1500, Alte Pinakothek, Munich. Some believe this to be Hans, Dürer's younger brother.

■ Dürer, *The Holy Family*, 1496, Boymans-van Beuningen Museum, Rotterdam. A charming miniature in gouache, pen, and gold and only slightly larger than a postcard, this was created by Dürer as a New Year's greetings card.

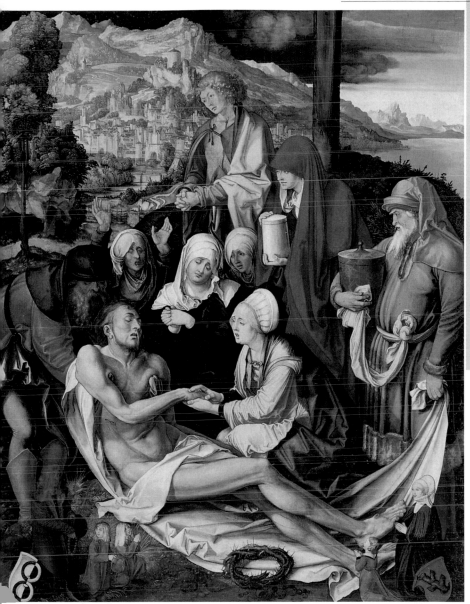

■ Dürer, *Lamentation over Christ*, 1500, Alte Pinakothek, Munich. A masterpiece of the developmental phase in Dürer's art, it was executed in Nuremberg for the goldsmith Gimm. The family and the coat of arms of the customer appear in the lower part of the plate. The placing of the figures according to different scales is a Gothic element within a monumental scene which is inspired by Italian models. An ample and varied landscape is the backdrop to the group of people surrounding the dead Christ.

1500-1507

The Paumgartner Altarpiece

Commissioned by the Paumgartner family for the church of St Catherine in Nuremberg, this is now housed in the Alte Pinakothek, Munich. It dates from 1502–1504.

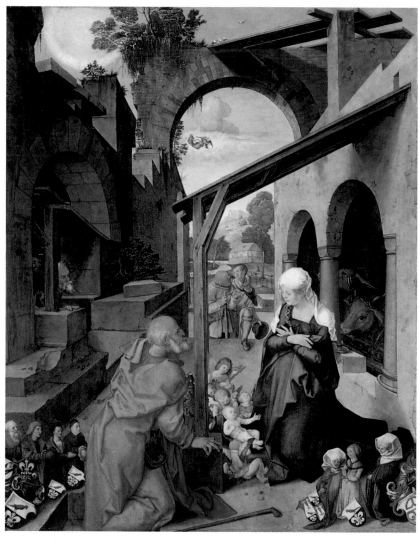

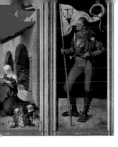

The opened-out triptych shows the *Nativity,* reduced in size within a perspectival, architectonic context, and the donors. To the sides, with a brusque shift in dimension, are two saints in armor.

■ This Madonna, painted almost in monochrome in light shades, is all that survives of the *Annunciation* painted on the side panels. It is housed in the Alte Pinakothek, Munich.

■ The side saints , probably portraits of the Paumgartners, may be identified by symbolic features: the dragon denotes St George, the standard with the stag's head denotes St Eustace.

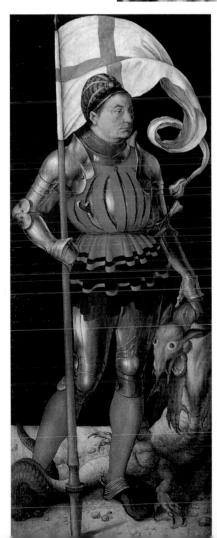

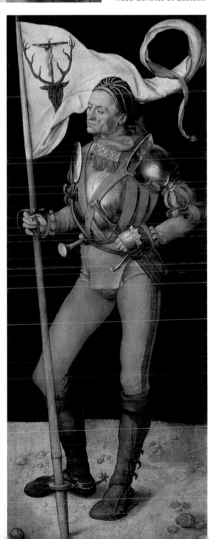

The death of his father and Dürer's new responsibilities

N ow over 30 years old, Albrecht Dürer could be considered reasonably comfortable although not wealthy: he and his wife Agnes continued to live in the parental home. His father's death in 1502 meant that Dürer had to take on the role of head of the family and provide for everyone by means of, among other things, the publication and sale of series of engravings such as the *Life of the Virgin*. The artist took legal responsibility for his mother Barbara and reorganized the workshop, with the help of his brother Hans.

■ Dürer, *Portrait of the Artist's Mother*, 1514, Staatliche Museen, Berlin. Dürer executed this bitter, almost ghostly drawing just two months before the death of his mother, Barbara Holper.

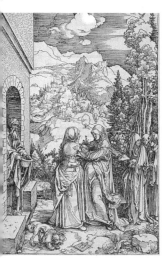

In 1503 Dürer was struck with an illness to his spleen: an outflow of bile convinced him conclusively that he was suffering from melancholia and that he was one of those artists who produce great works through their suffering and tribulations. As the *Adoration of the Magi* shows, the artist was now ready for a second journey to Italy where he could stand on an equal footing with the great masters of the Renaissance.

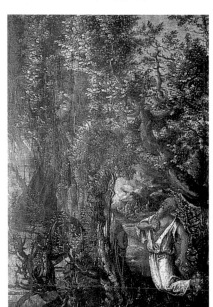

■ Dürer, *Visitation*, 1501–02. One of the engravings from the *Life of the Virgin* series.

■ Hans Dürer, *St Jerome*, Cracow Cathedral. Dürer's younger brother spent part of his career in Poland.

■ Dürer, *Adoration of the Magi*, 1504, Galleria degli Uffizi, Florence. Possibly painted for Frederick of Saxony, this is one of the most important works to precede the second journey to Venice. There are references to Italian art in the arrangement of the figures and the archeological elements of the landscape. Dürer portrays himself as the Wise Man with the gaudiest apparel, with long, wavy hair, laden with jewels and necklaces. The golden gifts recall his father's craft.

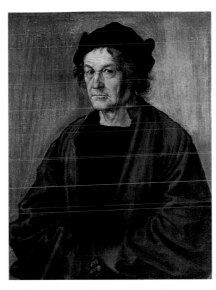

■ Dürer, *The Painter's Father*, 1497, National Gallery, London. Regarded by many as an old copy of a lost original, this is a powerful portrait of the ageing goldsmith from Hungary who came to seek his fortune in wealthy Nuremberg.

■ Leonardo da Vinci, *Adoration of the Magi*, detail of the background with ruins and knights, 1482, Galleria degli Uffizi, Florence. The similarity with the background in Dürer's painting is remarkable although Dürer would almost certainly not have known this work, which was intended for a small Florentine convent and remained unfinished.

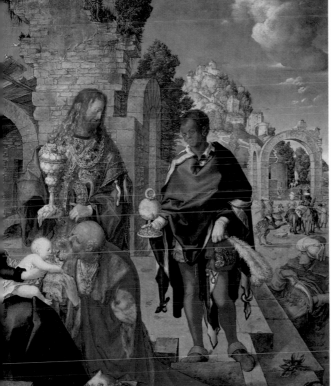

The myth of Venice

B etween 1505 and 1507 Dürer was once again in Italy. His stay, as guest of the powerful Fugger banking family, enabled the German artist, now in his prime, to experience the culture of the Italian Renaissance at the peak of its splendor. Dürer visited Padua, Bologna, and Pavia and spent a long time in Venice, the memory and myth of which remained irresistible for him. Painting was at this time moving between the tradition of the Bellini brothers and Carpaccio and the new generation led by Giorgione, Lorenzo Lotto, and Titian and one of the most stimulating periods in the entire history of European art. During Dürer's journey the Most Serene Republic and the Empire were at peace but in 1508, following the artist's return to Nuremberg, Maximilian of Hapsburg unleashed the offensive of the Holy League against Venice.

■ Lorenzo Lotto, *The Holy Conversation*, 1504, parish church of Santa Cristina al Tiverone, Treviso. This is one of the most "northern" altarpieces in Venetian art.

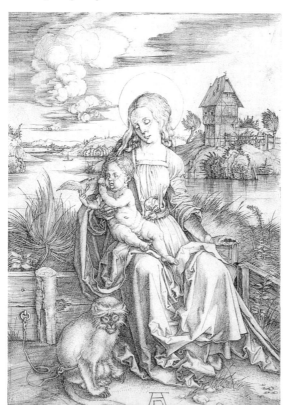

■ Dürer, *Madonna with the Monkey*, 1505. The classical feel is evidence of his relationship with Italy but, the wooden house on the right, by a pond, recalls the area around Nuremberg.

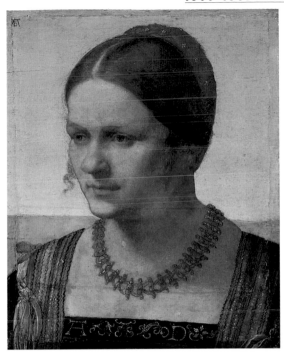

■ In the imagination of a late 15th-century German cartographer Venice appears as a fabled Gothic city studded with towers, spires, and crenellated buildings.

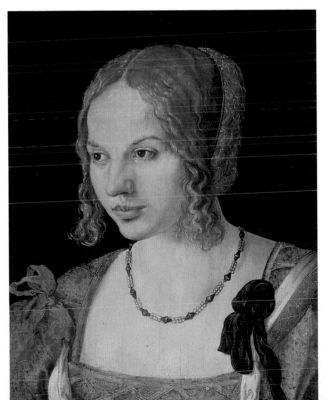

■ Dürer, *Portrait of a Venetian Woman*, 1506–07, Staatliche Museen, Berlin. Here Dürer adheres to the delicate, shaded tones of Venetian art. The artist's initials are embroidered in gold on the bodice.

■ Dürer, *Portrait of a Young Italian Woman*, 1505, Kunsthistorisches Museum, Vienna. This is the most famous female portrait Dürer painted in Italy. The cut of the dress and the deliberate inclusion of Leonardesque stylistic features indicate that the subject may have been a Milanese woman.

45

1500-1507

The study of perspective and Italian humanism

The main reason for Dürer's return to Italy was not so much to have contact with other painters as to master the scientific theory and techniques of perspective. He was particularly keen to meet Luca Pacioli at the University of Bologna, a friar who was a mathematical scholar and author of the famous algebra treatise *De Divina Proportione*, partly derived from the teachings and demonstrations of Piero della Francesca. An edition of this work exists, illustrated by Leonardo. The meeting between Dürer and Pacioli was arranged by the painter and engraver Jacopo de' Barbari, whom Dürer had known in Nuremberg. Dürer, who despite his admiration for Italy felt himself proudly German, was aware of the need to give a theoretical basis to Renaissance art north of the Alps. An encounter with humanists and scholars of perspective was indispensable to set out a treatise intended for German artists.

■ Illuminated frontispiece of one of the four surviving manuscript copies of *De Divina Proportione*, the fundamental treatise on the golden section.

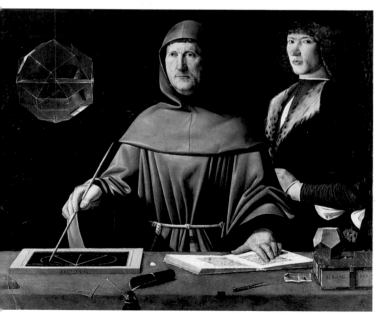

■ Jacopo de' Barbari (attributed), *Portrait of Luca Pacioli with an Assistant*, c.1500, Musei e Gallerie di Capodimonte, Naples. The friar is illustrating the theorems from his book on a blackboard.

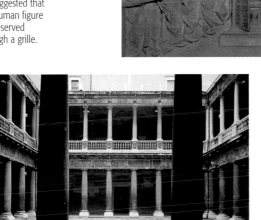

■ To illustrate his treatise on painting Dürer prepared this engraving, in which he suggested that the human figure be observed through a grille.

■ A characteristic tribute to the most celebrated teachers at the University of Bologna, these reliefs show the professor at his desk surrounded by students taking notes. Dating from the 14th and 15th century, most of these are housed in the Civico Museo Medievale, Bologna.

■ The forecourt of the University of Padua (known as"il Bo") to this day appears in its sober, composed 16th-century guise. In Dürer's day, Padua was one of the main centres for humanist studies in northern Italy.

■ Donatello, *The Miracle of the Mule*, detail, c.1450, Basilica del Santo, Padua. Donatello's bas-reliefs and bronze sculptures for the high altar were a veritable training ground in perspective for all artists passing through Padua.

BACKGROUND

Merchants and intellectuals in Italy and Germany

■ Giorgione, *Nude*, 1508, Ca' D'Oro, Venice. The frescos on the exterior of the Fondaco dei Tedeschi in Venice, by Giorgione and Titian, have almost all disappeared.

■ Bartolomeo Veneto, *Portrait of a Young Nobleman*, Galleria Nazionale d'Arte Antica, Rome. An excellent portrait painter, steady and clear in his draughtsmanship, Bartolomeo was one of the Venetian painters who was most influenced by Dürer.

On the eve of the 16th century, before new commercial routes shifted the axis of the European economy towards the Atlantic, Venice was possibly the most thriving commercial centre in continental Europe. Thanks to its location and its traditional role as meeting place between East and West, the Most Serene Republic was the centre of busy trading, with delegations from different countries opening up *fondachi* (stores) in the city, centres that housed warehouses, emporia, stock-exchanges, and places where imported and exported goods could be traded. Bustling communities of foreign residents also settled in Venice, giving the city a cosmopolitan feel and enriching its culture. The German community was one of the largest and most active, also as regards the commissioning of works of art. They also brought with them a cultural contribution, mainly in their patronage of the nascent printing presses. The Germans entrusted the restoration of their *fondaco* to a fellow national, commissioning the altarpiece in the confraternity's chapel from Dürer. The outer walls, however, were frescoed by Giorgione and Titian.

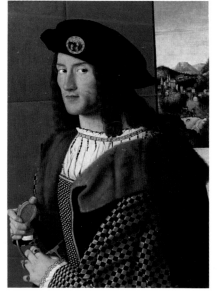

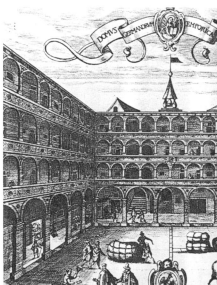

■ The inner courtyard of the Fondaco dei Tedeschi in a late 16th-century engraving. Often reorganized and adapted to new functions, this Renaissance building next to the Rialto bridge is today home to Venice's main post office.

Willibald Pirckheimer

This splendid engraving by Dürer shows us his best friend Willibald Pirckheimer. A friend of Durer's since childhood, Pirckheimer was educated as a European intellectual. He invited Dürer to the University of Pavia during the artist's first journey to Italy, then engaged him in a correspondence which was a blend of deep humanist reflections, obscene jokes, and considerations on art and Italy. In Venice he purchased classical literature texts, finally building up the finest library in Nuremberg. Although suffering from gout and dreadful obesity, he was a lucid interpreter of his time. He embraced the ideals of the Reformation, but returned to Catholicism having been disillusioned by Luther's excesses.

■ Dürer, *Portrait of Gerolamo Tedesco*, 1506. The architect, who built the Fondaco dei Tedeschi, also appears in the *Feast of the Rose Garlands*.

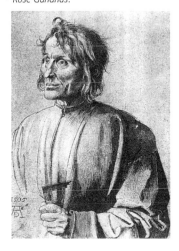

49

The Feast of the Rose Garlands

This altarpiece, the most important evidence of Dürer's second journey to Italy, was executed in 1506 for the church of San Bartolomeo di Rialto, where the German merchants used to gather. It is housed in the Narodni Galerie, Prague.

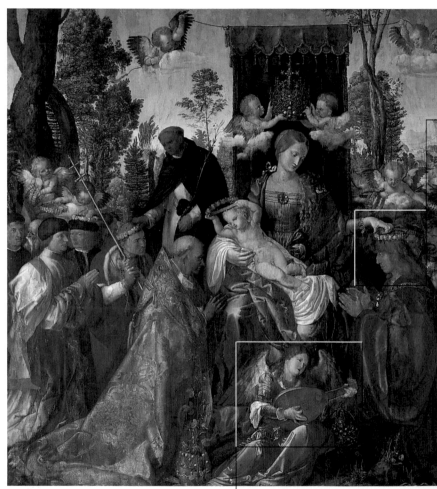

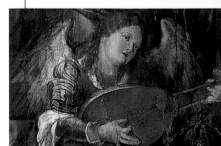

■ The angel playing the lute at the foot of the Virgin's throne is a clear tribute to the Venetian tradition, which abounds with many similar references (Giovanni Bellini, Carpaccio, the Vivarini). It is one of the clearest elements in what is otherwise a poorly preserved picture.

■ Many figures of the time, chiefly Germans, are portrayed in the altarpiece, not all of them identifiable with any certainty. Among others there is Jakob Fugger, the Augsburg banker and head of the German community in Venice. In a prominent position are Pope Alexander VI Borgia and Maximilian of Hapsburg (right), on whose head the Virgin places a rose garland.

■ In the background (which only serves to isolate him and make him more easily recognizable), Dürer portrays himself among the onlookers. He holds up a scroll written in Latin with his signature, the date, and a note recording that the altarpiece took five months to complete.

■ On the far right is a portrait of the architect Gerolamo Tedesco, who was responsible for restoring the Fondaco in sober and solid Renaissance forms after a devastating fire in 1505.

The conflict between beauty and time

■ Dürer, *Portrait of a Young Man*, 1507, Kunsthistorisches Museum, Vienna. Painted in Venice, this is probably the picture of a young German merchant or the son of one of the leading figures in the Fondaco. Painted on the reverse is *Avarice* (below), which appears in sharp contrast to the docile face and delicate shading of the man's portrait.

Inspired by the example of Giorgione and, more widely, caught up in the intellectual and artistic debate about the "three ages of man" and the transience of beauty, Dürer expanded on the theme of the human body during his second journey to Italy. From this point, his researches were twofold: on the one hand there was the intellectual, driven in search of a utopian canon of beauty based on geometric relationships and on the harmony of the parts of the human body: on the other hand there was the artist, able to catch nuances in expression and personality, wanting to explore the opposing subjects of youth and old age, prepared to defy any codification in order to register his vision of nature with poetic realism. It may have been during these very years, probably the greatest in his career, that Dürer came to be aware of the irreconcilable contradiction which would dominate his life from this moment on: an unbridled love for the most varied aspects of nature and his wish, which was constantly thwarted, to find general, objective, and immutable rules to define beauty. Dürer's perception of the marvellous variety to be found in the natural world was a precise one and, as an excellent portrait painter, he knew how to catch the transitory flash of beauty. The other side of the coin, however, was that he could also see degradation, unpleasantness, and withering.

■ Giorgione, *The Old Woman*, c.1508, Gallerie dell'Accademia, Venice. The old woman, her expression and features distorted by age, bears a note in her hand with the admonishment COL TEMPO (with time), presenting herself as the disaffected destiny of earthly beauty.

■ Dürer, *Portrait of a Girl in a Red Cap*, 1507, Staatliche Museen, Berlin. Painted on vellum laid down on wood, it shows a person of disturbing beauty: possibly a young girl, a youth, or a child. This is a delicate image of a newly burgeoned beauty, which seems to stand deliberately away from gender to put itself forward as an absolute archetype.

■ Dürer, *Avarice*, 1507, Kunsthistorisches Museum, Vienna. The toothless, repulsive old woman, with an obscene leer, clutches a money bag: this is the symbolic image of avarice, but also a disarming vision of physical and moral degradation. Showing clear stylistic affinities with Giorgione's *Old Woman*, the picture represents the other side of the search for a canon of physical beauty along geometric lines. Dürer, although mindful of the financial implications of his activity and careful with his domestic book-keeping, was not a mean man. On the contrary, he displayed a prodigal quality on more than one occasion, moved by a genuine spirit of charity.

Adam and Eve

Signed and dated 1507, the two panels are connected and are preserved next to one another in the Prado, Madrid. Executed by Dürer while he was in Italy, they are the first life-sized nudes in German painting.

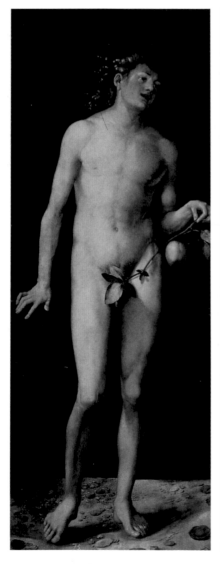
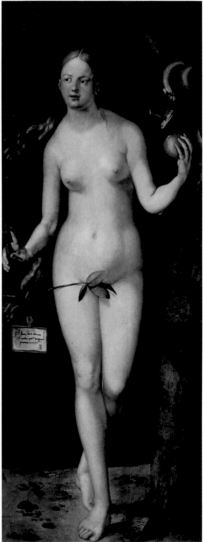

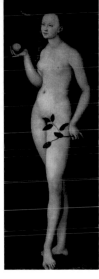

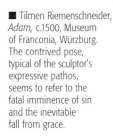

■ Tilmen Riemenschneider, *Adam*, c.1500, Museum of Franconia, Würzburg. The contrived pose, typical of the sculptor's expressive pathos, seems to refer to the fatal imminence of sin and the inevitable fall from grace.

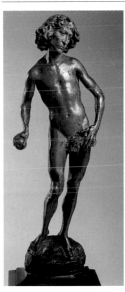

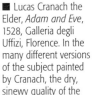

■ Lucas Cranach the Elder, *Adam and Eve*, 1528, Galleria degli Uffizi, Florence. In the many different versions of the subject painted by Cranach, the dry, sinewy quality of the northern drawing tradition continues to be felt, despite his care over anatomical proportions. Even his use of chiaroscuro is much less soft and sensual than Dürer's.

■ Hieronymus Bosch, *Original Sin*, detail from the *Hay Wain*, c.1500, Museo del Prado, Madrid. This is an example of the nordic conception of the painted nude, which was slender, stylized, and modest. Dürer's move away from this tradition is evident not only in the shape of his figures but most of all in his monumental and direct conception of the images.

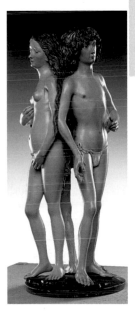

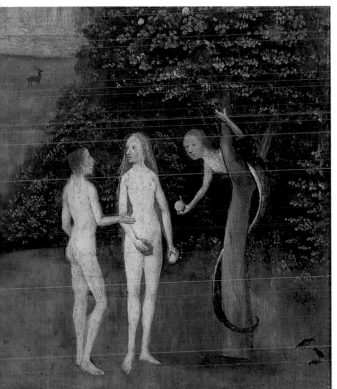

■ Nicolas Gerhaert, *Allegory of Vanity*, c.1500, Kunsthistorisches Museum, Vienna. A wizened old woman joins the two young figures from the rear.

Contemplating the world of nature: an encyclopedic mind

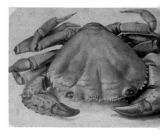

While he was concentrating on male and female nudes, Dürer never lost sight of the natural world. His zoological and botanical drawings rank with similar works produced at the same time by Leonardo. The two masters were motivated by similar interests, but while Leonardo seemed to want to project each fragment of nature into the macrocosm of a pantheistic organism, Dürer was able to focus on animals, flowers, herbs, landscapes, depicting them directly as he saw them. While Leonardo sought to blend all natural phenomena into a whole, Dürer preferred to produce a systematic series of observations on the environment, like individual paragraphs in an absorbing encyclopedia of nature. Dürer's interest in animals accompanied him throughout his long career, from the monstrous sow of Landser to the beached whale on the Dutch coast, the stag attacking the walrus, the artist seized every chance to study exotic or curiously formed animals. For his nature drawings, Dürer often opted for the watercolor technique, with elegant results, which gives the works a delicacy of color and a striking lifelike quality. Nature, in all its beauty and quirks, remained a life-long and all-consuming interest, and provided the theme for some of his finest work.

■ Dürer, *Sea Crab*, 1495, Boymans-van Beuningen Museum, Rotterdam. One of the first animal watercolors to have a plain white background, a technique Dürer would later frequently employ.

■ Dürer, *Madonna with the Monkey*, detail. Dürer places an unusual animal next to the Virgin.

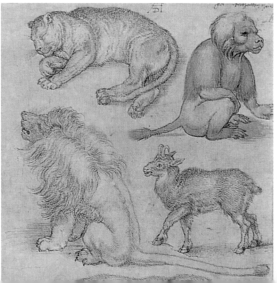

■ Dürer, *Young Hare*, 1502, Albertina, Vienna. One of Dürer's most famous nature watercolors, it shows a young hare in a room which is reflected with impressive skill in its eye. The ears are drawn up in fear, and the artist succeeds in conveying to us all his tenderness for the animal.

■ Dürer, *Virgin with a Multitude of Animals*, 1503, Albertina, Vienna. In a harmonious vision of paradise on Earth, the Madonna is surrounded by a domestic zoo.

■ Dürer, *Lion*, 1494, Kunsthalle, Hamburg, This watercolor drawing does not show a real lion but interprets the traditional image of the lion of St Mark in a naturalistic way.

■ Dürer, *Various Exotic Animals*, c.1500, J.J. Johnson Collection, Philadelphia. Dürer took every opportunity to study exotic animals, often with interesting distortions.

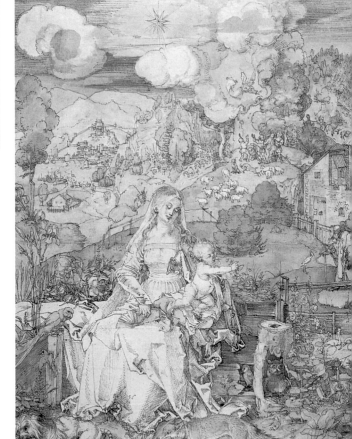

The vision of St Eustace

An engraving dating from 1500, this is perfect proof of Dürer's love of nature: the hunter saint kneels at the sight of a stag bearing a crucifix between his antlers.

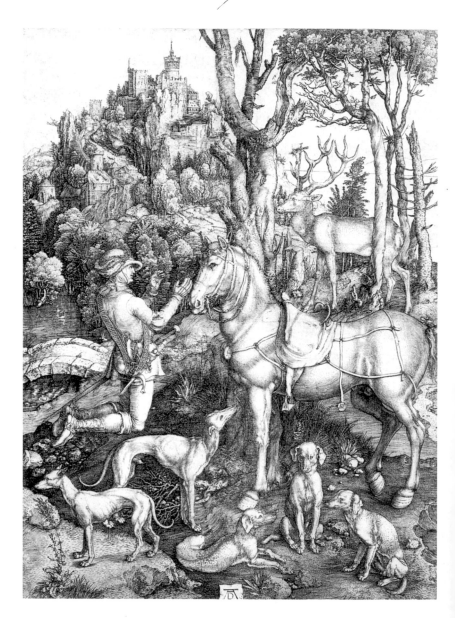

like fantasy, Dürer demonstrates a genuine love for the animals that are hidden in the forest, portraying them wherever possible from life.

■ Pisanello, *The Vision of St Eustace*, c.1440, National Gallery, London. Executed for the court of the Gonzagas, this painting is a gem of European late-Gothic art. As always, Pisanello includes sharply realistic details within the narrative context of a charming fairy tale. The excited greyhounds are similar to those engraved by Dürer, revealing the influence of the best naturalistic tradition of International Gothic on both artists.

■ Life of the Virgin Master, *The Conversion of St Hubert*, c.1470, National Gallery, London. In Germany, abounding with woods which provided hunting-grounds for the nobility, the meeting between Saint Eustace or, as here, St Hubert and the divine stag is one of the most frequently painted scenes in the 15th century. Dürer's departure from German tradition is evident.

The example of Leonardo da Vinci

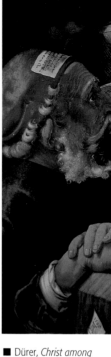

It is likely that during his two visits to Italy, most probably during the second one (1505–07), Dürer met Leonardo in Milan. Willibald Pirckheimer was a student at the University of Pavia and he probably invited his friend to spend some time with him in Lombardy. Leonardo, having returned to Milan after a period in Florence, was at that time completing works such as the *Virgin with St Anne* and the *Mona Lisa*. Direct contact between Dürer and Leonardo, or at least a study of each other's work, can help us to understand the considerable spiritual affinity between the two artists, who both saw man as an integral part of a vast natural organism. A further common quality was their desire to study and reproduce beauty and ugliness, the angelic and the grotesque. Traces of Leonardo's influence may be seen in many of Dürer's works but, as was also the case with Venetian painting, this was never reduced merely to a superficial reproduction of certain stylistic elements but was more of a deep vision of the world to which Dürer addressed his own sensibility. The same can be said for the alleged meeting between Dürer and Bosch. In some paintings Dürer introduces peculiar characters which are similar to those created by the imaginative Dutch artist. Their meeting may have taken place in Venice.

■ Dürer, *Christ among the Doctors*, 1506, Thyssen Collection, Madrid. An unusual painting in Dürer's output, this was executed in Venice at the same time as, and almost as the antithesis of, *The Feast of the Rose Garlands*. The contorted features of the doctors arguing with the 12-year-old Jesus recall both Leonardo and Bosch.

■ Lorenzo Lotto, *The Holy Conversation*, 1508, Galleria Borghese, Rome. The success of *Christ among the Doctors* was immediate, as this work shows: the figure of St Onophrius, on the right, is clearly drawn from Dürer's bearded figure in the same position.

■ In Leonardo's drawings there is a vast range of physiognomies and expressions: the juxtaposition of very different faces is a fascinating feature of his work, such as this old man, who is placed before a youth of divine beauty.

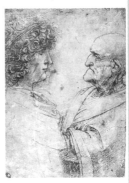

■ Dürer, *Nemesis*, or *Fortuna*. One of Dürer's most famous engravings, this allegory shows a bird's eye view of the landscape, a feature often seen in some drawings by Leonardo da Vinci.

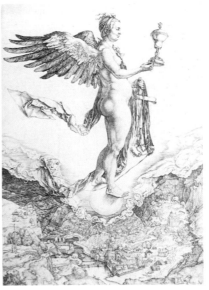

■ Leonardo, *The Virgin with St Anne*, detail, c.1508, Musée du Louvre, Paris. A further, unparalleled demonstration of vibrant feeling diffused throughout the atmosphere of the landscape and around the figures. The mountains in the background anticipate similar views by Dürer.

The Great Piece of Turf

Housed in the Albertina, Vienna, this is one of
the most famous nature pictures of all time.
Viewed low down, a small clump of grass and
flowers becomes a forest which is full of life.

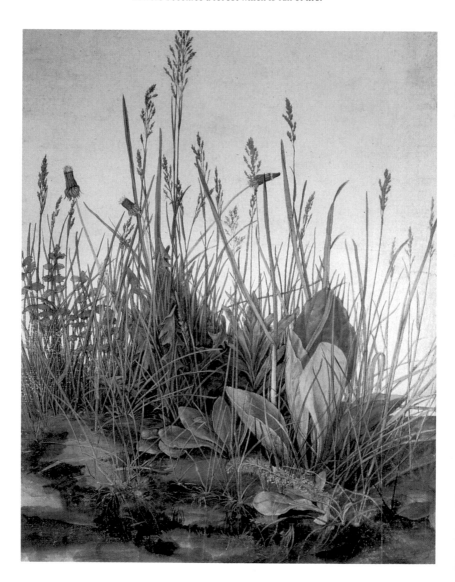

■ Dürer, *Wing of Blue Bird*, 1512, Albertina, Vienna. Dürer's nature watercolors form an independent collection in his output. In some works he concentrates on the appearance of animals, flowers, herbs; in others, as here, he reproduces their colors, with extraordinary results.

■ Dürer, *Elk*, 1504, British Museum, London. This watercolor drawing shows the importance Dürer attributed to the study of animals. It dates from 1504, but the artist has added 15 years to this, and a brief legend, the monogram, and the date, 1519. This shows that Dürer kept the drawing, using it for comparisons and sketches.

■ Dürer, *Spruce Tree (Picea Abies)*, 1495–97, British Museum, London. Dürer's passion for nature manifested itself most of all during his journeys south of the Alps. In the watercolors he produced while travelling the artist reproduced rocks, water, woods and meadows, or individual trees, such as this fir tree, isolated and exalted with its pointed green foliage.

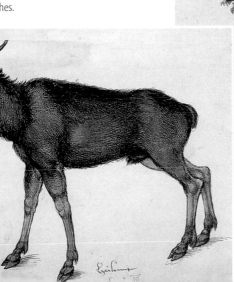

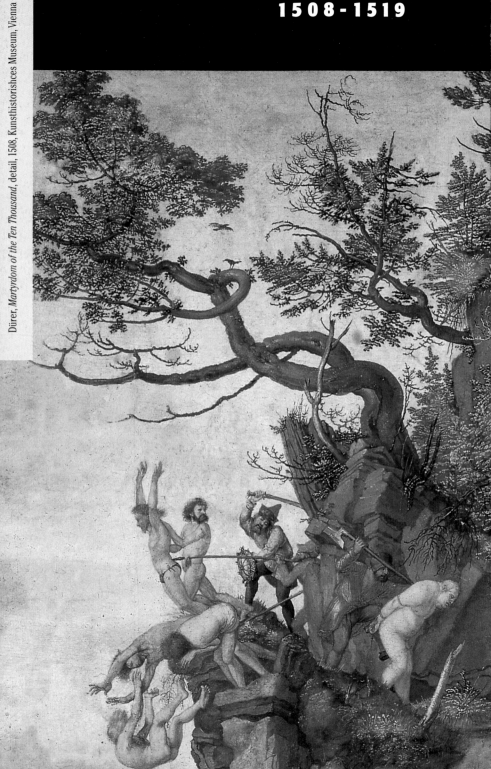

Dürer, *Martyrdom of the Ten Thousand*, detail, 1508, Kunsthistorishces Museum, Vienna

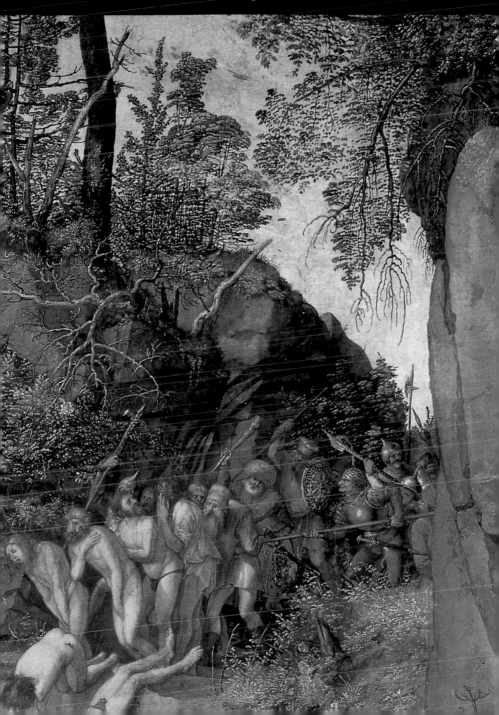

Wealth and social obligations

The Dürer who returned home after the years spent in Italy was a new man: more cultured, more determined, and also wealthier. In 1509 he was finally able to buy his own house, a large, exclusive wooden dwelling in the Zistelgasse, in the immediate vicinity of the castle, for which he needed no loan. This is the famous Dürerhaus, one of the most frequently visited sights in Nuremberg. A period of tranquillity now began for the artist; he was one of the most authoritative figures in the city and he frequently attended a number of civic gatherings. Drawing on the experiences of his Italian fellow artists, Dürer succeeded in modifying the social role of the artist: he was no longer a craftsman endowed with particular manual skills but an intellectual, an interpreter of history, a moral and cultural point of reference for the townspeople. His attitude to patrons also underwent a dramatic change: he was no longer intimidated by even the most powerful lords, considering himself to be an equal rather than a subordinate on whom tasks could be imposed, and behaved accordingly, setting the dignified power of art against that of politics.

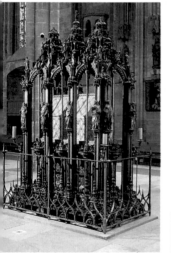

■ Bombing during World War II severely damaged the city of Nuremberg: besides the main monuments, only a few parts have been well preserved, such as the Gothic hospital of the Holy Spirit on the banks of the Pegnitz, the river which flows through the city.

■ The splendid bronze reliquary tomb of St Sebaldus in the church of the same name in Nuremberg: executed from 1508, it was the work of the goldsmith Peter Vischer and his five sons.

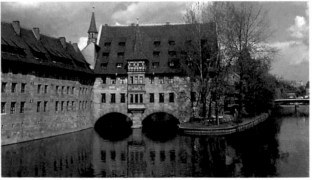

■ Dürer, *Bird with Wings Outstretched*, 1513, British Museum, London. This watercolor drawing with an enigmatic motto, must have been intended for a heraldic use.

■ Dürer, *Ecce Homo*, 1509–12. This engraving is part of the elegant *Small Passion* series of engravings, which were immediately diffused throughout Europe.

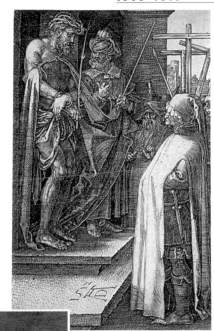

A well integrated eccentric

This further self-portrait of Dürer's is a detail from the *Adoration of the Trinity* (Kunsthistorisches Museum, Vienna). The flamboyant clothes, the carefully arranged hair, and his presence within a painting showing a gathering of saints are clear symbols of the artist's social standing; on the other hand, the flash of genius in the gaze is inescapable, piercing through all conventions, peremptorily expressing the artist's freedom. The social position he had achieved did not, however, make him aloof. On the contrary, Dürer made a generous personal commitment to the public life of his home town and was always a respected figure.

The court of Maximilian of Hapsburg

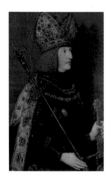

■ Bernhard Strigel, *Maximilian I*, 1507, Landesmuseum, Innsbruck. Although not as intense, this is a much less pompous portrait than Dürer's (see pages 71–71).

From 1513 Dürer became involved in the ambitious artistic aims of Maximilian I of Hapsburg. The emperor, who resided at Innsbruck with his court, could not afford magniloquent works of architecture and saw that he would have to resort to cheaper means, such as engraving, to celebrate himself. He thus entrusted Dürer, together with the architect Johannes Stabius and the engraver Hyeronimus Andreae, with the artistic direction of two complex projects: the *Triumphal Arch* and the *Procession*, enormous series of prints (192 and 138 sheets respectively, mounted together). If nothing else, these were a technical masterpiece in terms of the development of engraving. The many prints were produced by different artists, and distributed throughout the kingdom as propaganda. As a reward for these arduous works (which are, however, not without some delightful inclusions), the emperor suggested to the city of Nuremberg that Dürer should be exempt from paying taxes, but the town council proposed instead that Maximilian pay the artist an annuity of 100 florins to cover his taxation expenses. Finances aside, working for the emperor enabled Dürer to make contact with one of the liveliest humanist centers north of the Alps.

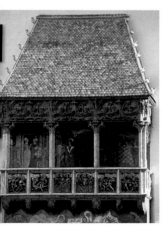

■ The *Golden Canopy*. The covered Renaissance roof terrace with gold tiles is the symbol of Innsbruck.

■ In a Flemish illuminated codex dating from the late 15th century, the young Maximilian sits alone and almost stunned on the throne, surrounded by the emblems of power: sword, orb, and ermine cloak.

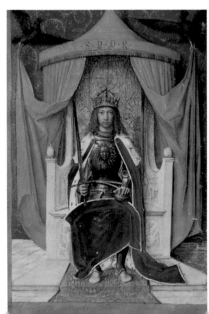

■ Dürer, *Courtyard of the Hofburg in Innsbruck* or, *City Square*, c.1494, Albertina, Vienna. The date and exact place depicted are not certain, although it seems that Innsbruck's Hofburg can be recognized. The imperial palace, restored in the 18th century, now has a pleasing Rococo appearance.

■ Bernhard Strigel, *Bianca Maria Sforza*, 1505–10, Landesmuseum, Innsbruck. The emperor's second wife was Milanese, a niece of Duke Ludovico il Moro. Because of this, many Italian men of letters moved to Vienna after the French conquest of the Sforza duchy.

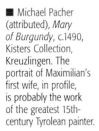

■ Michael Pacher (attributed), *Mary of Burgundy*, c.1490, Kisters Collection, Kreuzlingen. The portrait of Maximilian's first wife, in profile, is probably the work of the greatest 15th-century Tyrolean painter.

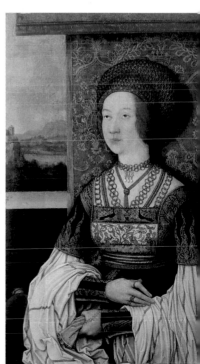

1508-1519

Portrait of the Emperor Maximilian I

Dürer seldom met the emperor. As the inscription specifies, the portrait, housed in Vienna's Kunsthistorisches Museum, dates from 1519.

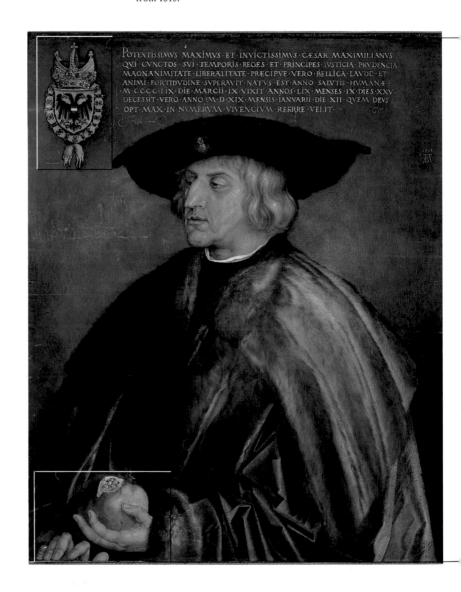

■ Another version of
Maximilian's portrait,
also painted by Dürer
but not so well

preserved, is housed
in Nuremberg's
Germanisches Museum.

■ Dürer, Preparatory
Sketch for the
Emperor's Portrait,
1518, Albertina,
Vienna. Dürer
sketched this from
life, when Maximilian
was in Augsburg to
attend the Diet on
June 28, 1518.

■ Dürer elegantly
works in the obligatory
heraldry, combining
the imperial insignia
(the two-headed eagle
with the Austrian colors
and the double-pointed
crown) with the personal
emblem of the collar
of the Order of the
Golden Fleece.

■ Maximilian holds a
pomegranate, symbol
of the unity between the
houses of Austria and
Spain. The two parts
of the empire would
be reunited by his
successor, Charles V,
lord of the immense
territory "on which
the sun never set".

Painters and humanists at Augsburg

■ Albrecht Altdorfer, *Maximilian Supervising Works of Architecture*, 1515. This engraving is included among the almost 200 scenes of the *Triumphal Arch*, 700 copies of which were printed. This enormous undertaking was the result work produced of an extraordinary team of specialist artists, led by Dürer.

Cultured, refined, serious, steeped in humanism, with Italian connections, particularly after his second marriage to Bianca Maria Sforza, Maximilian wanted to give his alpine empire a new courtly appearance in the classical style. He also took every opportunity to enlarge it by means of successful military exploits, such as the conquest of Trieste and Gorizia. In 1501 he founded the University of Vienna, inviting many Italian intellectuals who had fled the duchy of Milan in 1499, following the French invasion. Farsightedly, he summoned the best artists from southern Germany to the court at Innsbruck, and employed Dürer, Altdorfer, Cranach, and Burgkmair at the same time. Among other leading cultural figures involved at court were the poet Conrad Celtis, the geographer Georg Peutinger, and the astronomer Erhard Etzlaub, who helped Dürer to create two engravings with the map of the world and the constellations of the northern hemisphere, and Willibald Pirckheimer himself, who dictated the lengthy inscriptions of the *Triumphal Arch*.

■ Dürer, *View of Innsbruck*, 1495, Albertina, Vienna. This moving watercolor dates from the artist's first journey to Italy.

■ A row of 28 bronze statues of king and heroines from antiquity forms the guard of honour at the sides of Maximilian's tomb in the Court Church at Innsbruck. It is possible that Dürer may have supplied the drawings for two of these impressive, spectacular giant figures.

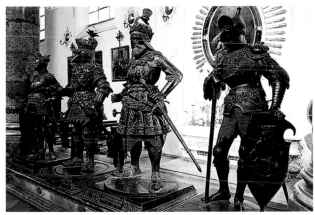

■ Dürer, *Self-portrait with Conrad Celtis*, detail from *The Martyrdom of the Ten Thousand*, 1508, Kunsthistorisches Museum, Vienna. The painter portrayed himself alongside the famous poet, the main literary figure at the University of Vienna.

■ The stunning appearance of the *Triumphal Arch,* fully mounted (1513–15).

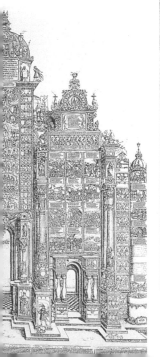

New expressive forms: illumination and sculpture

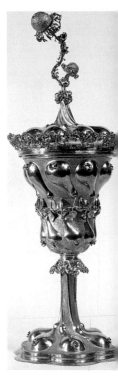

H aving reached his full artistic maturity, Dürer continued his painting and engraving activities but also allowed himself some skilled diversions into a few artistic genres which were unusual for him. He decorated the books in Willibald Pirckheimer's library with charming illustrations, and also became involved in the whirlwind production of Emperor Maximilian's illuminators. Although he produced no sculpture of his own, he drew and planned imaginative fountains, monuments, and candelabra in the shape of dragons or sirens. Even more interesting are his works in gold, executed using techniques he had learned in childhood, when he was apprenticed to his goldsmith father. All these works suggest an amusing series of hobbies on the part of the 40-year-old artist, but viewed as a whole, they show his consummate dominance over the most diverse aspects of the figurative arts, which he mastered with confidence and amusement, as well as in a spirit of creative freedom. Dürer also liked to design the frames for his own altarpieces, such as the *Adoration of the Trinity*.

■ Dürer, *Siren*, 1513, Kunsthistorisches Museum, Vienna. A delightful watercolor drawing, with the project for a fantastic candelabrum which may have been intended for a hunting lodge, as is suggested by the circle of stag antlers.

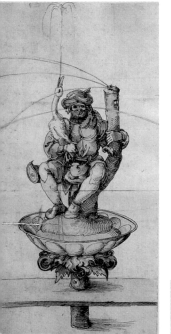

■ Dürer, *The Little Man and the Geese*, 1513, Kunsthistorisches Museum, Vienna. This is a project for a fountain with a popular Swiss-German theme.

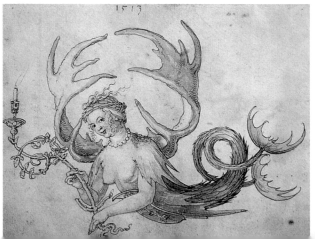

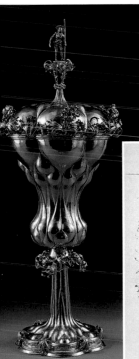

■ The illustrations around the edges of the *Book of Hours* of the Emperor Maximilian (employing a Latin text, but written in Gothic script) reveal a playfulness which is not unlike the fantastical drawings made by Altdorfer for the Austrian court. Dürer's output as an illustrator also includes drawings for Pirckheimer's books.

■ Dürer, *Maximilian Goblet* (left) and *Dürer Goblet*, c.1510, Kunsthistorisches Museum, Vienna. These two interesting ceremonial goblets in silver gilt, each measuring about 50 cm (19 in), are linked to German tradition. Both are aristocratic commissions and, although appearing to be similar, present small differences. The *Dürer Goblet* above, the older of the two by a few years, shows the late-Gothic legacy. The *Maximilian Goblet* has a more fluid form, with the naturalistic insertion of a row of pears around the edge.

75

The alpine watercolors

Dürer produced some interesting alpine landscapes during his journeys in the Trentino and the Tyrol, including *View of Arco* (below), 1495, Musée du Louvre, Paris.

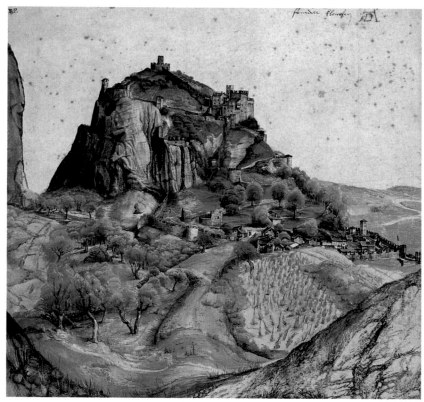

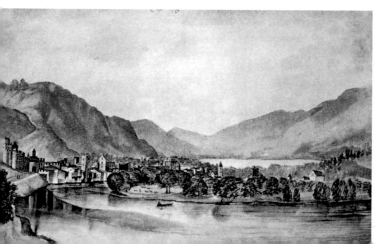

■ This view of Trent dates from Dürer's first journey toward Italy (1494). It was housed in the Kunsthalle, Bremen, but was destroyed during World War II.

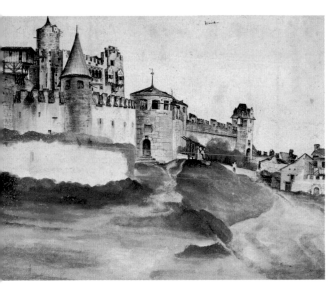

■ With the precision of an artist who had long engaged in engraving, Dürer outlined the clear profile of the *Castle of Trent* (1495, British Museum, London). The monumental building still appears in its late-Gothic guise, prior to the important alterations in the Renaissance style ordered by Bishop Bernardo Clesio.

Nature's body and soul

This watercolor showing a stone cave (Kupferstichkabinett, Berlin) is dated at around 1510. Compared with views of 15 years earlier, the development is clear: Dürer now seemed to be looking for the spirit of nature and not just its external appearance; he was pursuing a deeper meaning underlying it. With free, evanescent strokes, the painter evokes remote "romantic" scenes. Intimate, poetic traits appear throughout German art, though Dürer's interpretation of nature was way ahead of its time, resembling early 19th-century or Japanese painting.

Altdorfer: the wonders of nature

At the court of Maximilian I Dürer met Albrecht Altdorfer, one of the most original German painters of the early 16th century. Born around 1480, Altdorfer spent almost his entire working life in Regensburg, where he lived from 1505. An excellent draughtsman and elegant engraver, he was the main representative of the Danube School, which drew its inspiration mainly from supposedly magical forests. With light brushstrokes, Altdorfer's paintings evoke an atmosphere which is charged with feeling; his figures wear flamboyant clothing, in what are occasionally humorous compositions. Between 1509 and 1516 Altdorfer produced his largest and most complex work, the panelled altar for the Abbey at Sankt Florian (Linz), in which he reached a supreme level of poetry, painting the first "pure" German landscapes. After the Reformation he was mainly involved in the administration of the city of Regensburg, and was also its official architect.

■ Altdorfer, *The Departure of the Apostles*, 1517–19, Staatliche Museen, Berlin. The painting shows the moment in which the apostles bid each other farewell and set off in twos to pursue their evangelical mission.

■ Altdorfer, *The Recovery of the Body of St Sebastian*, 1509–16, Abbey, Sankt Florian (Linz).

■ Altdorfer, *Landscape with a Footbridge*, c.1516, National Gallery, London. This is one of the earliest examples of "pure" landscape in painting. Dürer commonly used watercolor for this type of subject.

■ Altdorfer, *Susannah at her Bath*, 1526, Alte Pinakothek, Munich. The biblical subject, approached with cheerful good humor, is a pretext to create a spectacular architectural background, with a building which is depicted in every smallest detail. In this same year Altdorfer was appointed official architect to the city of Regensburg and was frequently in charge of architectural projects.

LIFE AND WORKS

Official duties: the decoration of the Hall of the Insignia

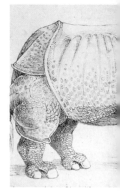

During the 1520s Dürer stifled his natural desire to travel and, particularly after the death of his mother Barbara (1514), he devoted himself to family life and to the running of the considerable business of his by now well established workshop. This was a quiet time in Nuremberg, which favored the creation of splendid works of art in its main churches. Now aged over 40, Dürer took a particular interest in his city, painting important works for two unique places, both sadly now destroyed, which blended civic pride and private devotion: The Hall of the Insignia, on the market place, intended for solemn civic ceremonies, and the Oratory of All Saints, within the sphere of the charitable confraternity set up by the pious benefactor Matthaeus Landauer. Dürer executed one of his most striking works for this chapel, the *Adoration of the Trinity* altarpiece.

■ Dürer, *Rhinoceros*, 1513. In 1513 The Portuguese merchants had brought to Lisbon the first Indian rhinoceros and the first Indian elephant ever seen in Europe. Dürer took a keen interest in these exotic animals; prints and drawings provided him with the elements for this famous engraving.

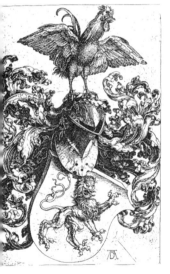

■ Dürer, *Coat-of-Arms with Lion and Rooster*, c.1503. As this bizarre engraving shows, Dürer was often called to produce heraldic insignia.

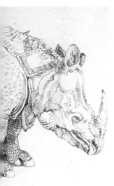

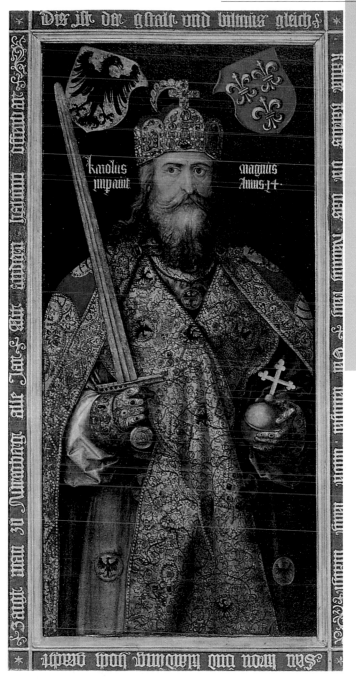

■ Dürer, *The Emperor Charlemagne*, 1512–13, Germanisches Museum, Nuremberg. Together with a companion panel depicting the Emperor Sigismund, Dürer produced this work to decorate the hall where Charlemagne's imperial insignia, donated to the city of Nuremberg by Sigismund in 1424, were exhibited each year.

■ This engraving enables us to reconstruct the former appearance of the Oratory of All Saints in Nuremberg with Dürer's altarpiece. The Gothic chapel, which underwent repeated modifications, was destroyed in World War II.

Adoration of the Trinity

Executed in 1511, with meticulous attention to detail, and now housed in the Kunsthistorisches Museum, Vienna, the altarpiece shows the gathering of saints around the Holy Trinity before the Last Judgement.

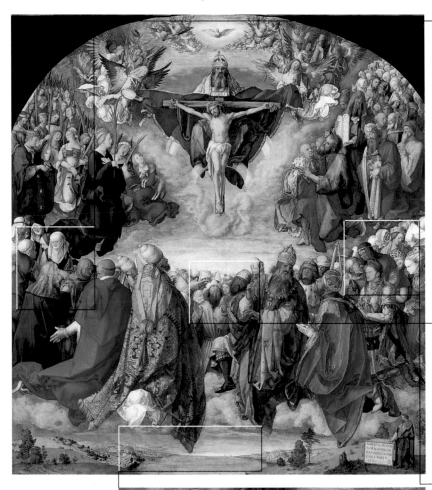

■ The landscape below, with the wide basin of a peaceful lake may be a memory of Lake Garda, which Dürer had admired during his journeys to Italy.

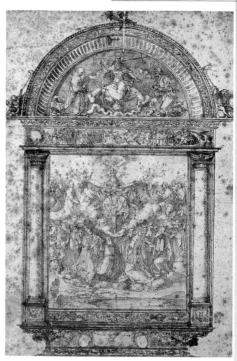

■ On the far left is the portrait of Matthaeus Landauer, who commissioned the work, shown in devout prayer.

■ Dürer, *Preparatory Study for the Altarpiece of All Saints*, 1508, Musée Condé, Chantilly. Dürer also designed the carved, gilded frame, which is still in Nuremberg.

■ The double semicircle of the saints placed around the central axis of the Trinity gliding through the sky can be compared with an analogous compositional structure adopted by Raphael in the *Dispute Over the Sacrament* fresco in the Vatican Stanze (1508).

■ Even within the majestic and classical nobility of its monumental composition, the altarpiece reveals many details in the figures' clothing which are typically northern, in a bold synthesis of art from both north and south of the Alps.

BACKGROUND

Jakob Fugger and the city of Augsburg

In 1517 Martin Luther posted his 95 theses in Wittenberg, in which he denounced the evils of the Church. A religious crisis broke out: Pope Leo X wanted to summon Luther to Rome, but the Elector of Saxony, Frederick The Wise, Dürer's patron, succeeded in arranging a meeting in Germany. The banker Jakob Fugger, one of the wealthiest and most powerful men in Europe, favored the setting up of a Diet, by way of conciliation and clarification, in his home town of Augsburg. Taking part in the discussions, besides Luther, were Emperor Maximilian and the Dominican canon Tetze. Dürer also took part in the debates, portraying some of the participants. From the religious point of view the Diet was a failure, but the city of Augsburg became well known throughout Europe, and entered the most dazzling period of its history, during which it enjoyed an unrivalled success. Thanks to its silver mines, Augsburg's goldsmiths were able to produce beautiful precious objects which would conquer the international market within a few decades, at Nuremberg's expense.

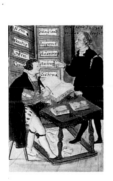

■ The banker Jakob Fugger with his secretary in his office, from an early 16th-century miniature, Bibliothèque Nationale, Paris.

■ Dürer, *Portrait of Jakob Fugger,* 1520, Alte Pinakothek, Munich. The painting is derived from the portrait Dürer drew two years previously during the Diet of Augsburg.

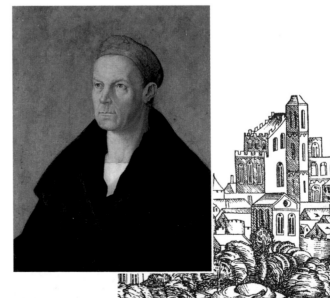

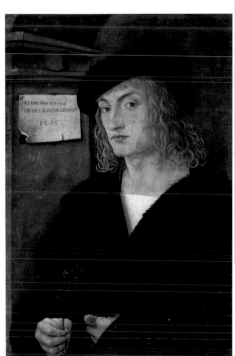

■ Hans Holbein the Elder, *St Elisabeth Giving Alms*, 1516, Alte Pinakothek, Munich. This work comes from the high altar of the Carmelite church in Augsburg.

■ Hans Burgkmair, *Portrait of Hans Schellenberger*, 1505, Wallraf-Richartz Museum, Cologne. This shows one of the wealthiest merchants in Augsburg.

■ A view of Augsburg, in an engraving by the geographer Hartmann Schedel, printed in Nuremberg in 1493.

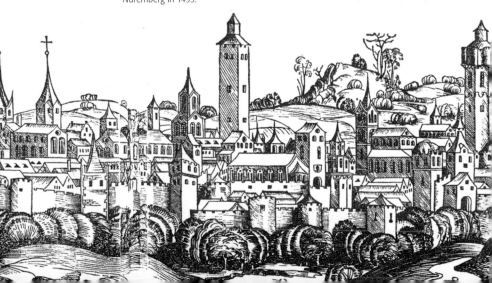

Madonnas

■ Dürer, *Madonna Suckling the Child*, 1503, Kunsthistorisches Museum, Vienna. The plain clothing, ordinary features, and smiling expression of the Madonna give this work a fresh and spontaneous feel.

Dürer was without question an extremely versatile artist who was able to dominate different subjects and areas of art with full technical mastery and a consistently confident style. He specialized in no single genre but, besides his portraiture, there is one theme which recurs throughout his career: the Madonna and Child. Dürer's entire stylistic development can be traced by looking at the dozens of Madonnas he painted, drew, or engraved during four decades of activity, from his majestic altarpieces to the smallest engravings. A profoundly human feeling is a constant feature in these works, together with the touching psychology of mother and child. Whereas Dürer was always ready to identify himself in the subjects he portrayed (as the abundance of self-portraits clearly shows), he rarely projected his own personal experience on to the theme of Madonna and Child. A significant exception to this, however, is the New York painting, in which St Anne, the mother of the Virgin, possesses the heavy features of Agnes, Dürer's wife. A careful study of Dürer's work as a whole reveals that the female image, whether human, maternal, or divine, played a fundamental and psychologically important role.

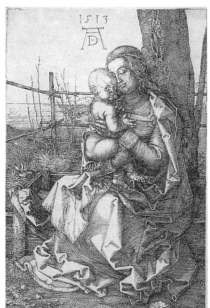

■ Dürer, *Madonna and Child*, 1506, Fondazione Magnani Roca, Mamiano (Parma). Probably executed in Bologna, this painting is a blend of German draughtsmanship, Giovanni Bellini's golden light, and Leonardo's precision.

■ The embrace between Mother and Child in this small engraving of 1513 conveys an intimate sense of tenderness.

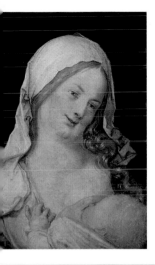

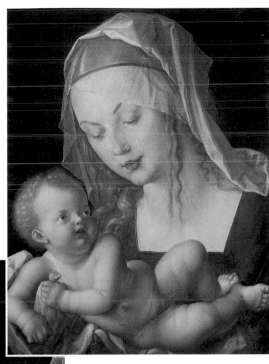

■ Dürer, *Madonna and Child*, 1512, Kunsthistorisches Museum, Vienna. Painted for the Pirckheimer family, it was bought by Rudolph II for his Prague collection.

■ Dürer, *Virgin and Child with St Anne*, 1519, Metropolitan Museum of Art, New York. Dürer portrayed his wife Agnes in the figure of St Anne.

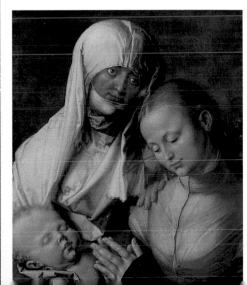

The plague and the Turkish threat: the clouds gather

BACKGROUND

■ *Gentile and Giovanni Bellini, St Mark's Sermon in Alexandria*, detail showing a group of Oriental notables, 1506, Pinacoteca di Brera, Milan.

In 1505 Dürer hurriedly left Nuremberg, as the nightmare of the plague loomed, a disease which Europe was unable to conquer and which returned in epidemic waves, spreading death and anguish. The plague brought with it fearful social consequences – "plague spreaders" were hunted down and the sick were abandoned. Venereal disease was also rife at this time, reputedly spread by Columbus' crew and by the advancing armies. From the Balkans came a new threat: the aggressive expansionism of the Ottomans, who attacked Venetian territories and eroded the Oriental provinces of Maximilian's empire. The fall of Belgrade, a town which had been regarded as impregnable, was a deep shock for Germany and for Europe as a whole, as it discovered the full might of the Turkish terror.

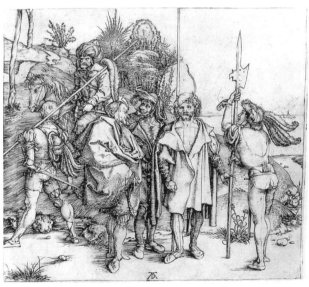

■ Dürer, *Five Lansquenets and an Oriental on Horseback*, 1495. Dürer portrays a menacing Turkish knight, quite different from the peaceful figures painted in Venice by the Bellini brothers.

■ Dürer, *Attack on the Castle of Hohenasperg*, 1519, Kupferstichkabinett, Berlin. In the last ten years of his life, following the wave of wars and violence which racked and bloodied Germany, Dürer took an interest in military tactics and the use of firearms.

■ Master of the Middle Rhine, *Allegory of Life and Death*, detail, c.1480, Germanisches Museum, Nuremberg. Not even humanist culture could wipe out the fear of death.

■ Gérard David, *Triptych of St Michael,* detail, 1510, Kunsthistorisches Museum, Vienna. Under the resplendent mantle of the Renaissance lurk the monsters of disease, poverty, discord, war, and the fear of the unknown.

Melencolia I

Produced in 1514, *Melencolia I* is possibly the
most magical of Dürer's engravings: a universal
masterpiece, its complex interpretation has
always intrigued scholars.

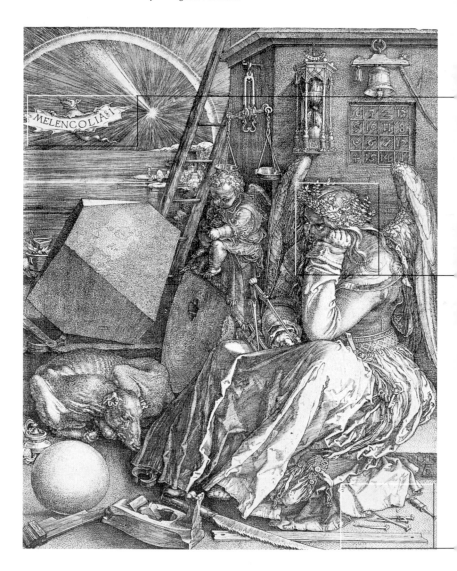

■ A bat with open wings bears the title of the work, which refers to the first state of melancholy, closely linked to alchemy. Matter, in a quiescent state, prepares itself to be transformed.

■ The main character in the scene is the allegorical winged figure who symbolizes melancholia. The girl's face is deliberately kept in the shadows: her sullen face suggests a state of mind which is still dark and troubled, like the black matter which was believed to be the first stage in early experiments into alchemy.

■ Carpaccio, *Meditation Over the Dead Christ*, c.1510, Staatliche Museen, Berlin. In this bitter painting, an old man under the tree in the background (perhaps the patriarch Job), pensively meditates in the same pose as the main figure in Dürer's *Melencolia I*.

■ The scene features several instruments, for the moment not in use, but ready to assist the artist's creative freedom as soon as the first wave of melancholia gives way to an unleashing of brilliant energy.

Engraved and painted portraits

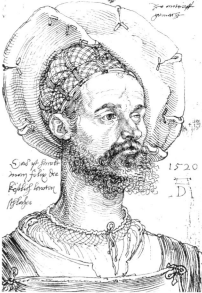

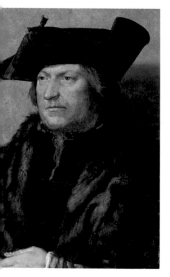

All his life Dürer persistently experimented with portraiture, particularly of male subjects, consolidating and developing his gift of impeccable precision in the rendering of detail. This, combined with an astute psychological insight into the sitter's mind, makes him one of the greatest portrait painters in history. Portraiture as a genre had previously been practised only rarely in Germany, but from Dürer's time, it became instead one of the prevalent themes in northern European art. The portraits Dürer painted in his mature years, unlike the more youthful ones, tend to be simpler, forsaking picturesque details of dress in favor of a search for a sober intensity.

■ Dürer, *Portrait of a Young Man*, 1506, Royal Collection, Windsor. Similar in style to Giorgione's work, this portrait shows a young German merchant who also features in the *Feast of the Rose Garlands* altarpiece.

■ Dürer, *Portrait of a Gentleman*, 1521, Isabella Stewart Gardner Museum, Boston, Mass.. The later portraits are severe and composed.

■ Dürer, *Captain Felix Hungersberger*, 1520, Albertina, Vienna. This picaresque-looking soldier is one of the earliest of many portraits and sketches Dürer produced during his journey toward the Low Countries.

■ Dürer, *Portrait of a Young Man*, 1506, Galleria di Palazzo Rosso, Genoa. This work was also painted during the course of Dürer's second journey to Italy, and confirms the artist's interest in Venetian art.

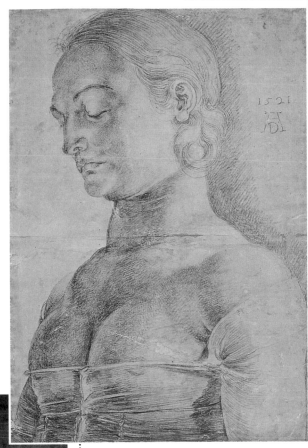

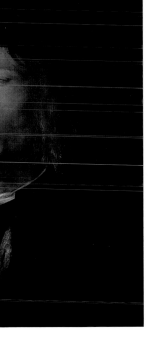

The appeal of simplicity

Dürer, *Study for the Figure of St Apollonia*, 1521, Kupferstichkabinett, Berlin. Though sensual, she remains dignified and restrained. Her introspective expression and the way in which the chiaroscuro is used, make this sturdy Teutonic girl the highest point in Dürer's search for an ideal beauty. Even though he finally used this drawing for the figure of a saint, Dürer has subtly captured a feature of eternal femininity.

The development of art in southern Germany

In the 16th century, German art enjoyed a period of splendor, particularly in the southern regions (Franconia, the Rhineland, the Black Forest). This buoyant time saw the activity of masters who were entering their prime (Dürer, Altdorfer, Cranach the Elder), the appearance of Holbein the Younger and, generally, a change in taste: patrons and public alike now seemed to favor polyptychs that were entirely painted rather than the traditional carved wood altars. A supreme example of this is the enormous structure painted by Matthias Grünewald for the convent of Isenheim in Alsace, now preserved in Colmar, which the artist filled with a tumultuous, dramatic expressivity. The first scene to be viewed by the spectator, the awesome *Crucifixion*, is an image of insuperable tragic force and one of the greatest masterpieces of all time. Dürer's work, which was well known and held in high regard, proved to be an important stimulus for German art as a whole at this time.

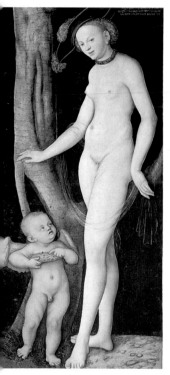

■ Lucas Cranach the Elder, *Venus and Cupid*, c.1520, Galleria Borghese, Rome.

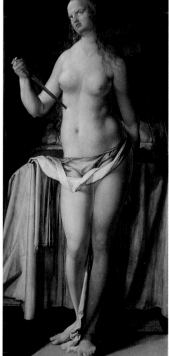

■ Dürer, *The Suicide of Lucretia*, 1518, Alte Pinakothek, Munich. A comparison between these nudes underlines Dürer's naturalistic use of chiaroscuro.

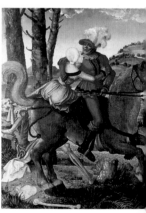

■ Hans Baldung Grien, *The Knight, the Maiden, and Death*, Musée du Louvre, Paris. In this work the Renaissance overlies the imaginary fabled world of chivalrous tales.

■ Lucas Cranach the Elder, *Crucifixion*, 1502, Kunsthistorisches Museum, Vienna. At the beginning of his long career, which was mainly spent in Saxony, Cranach revealed how he could approach traditional art themes with imagination and originality.

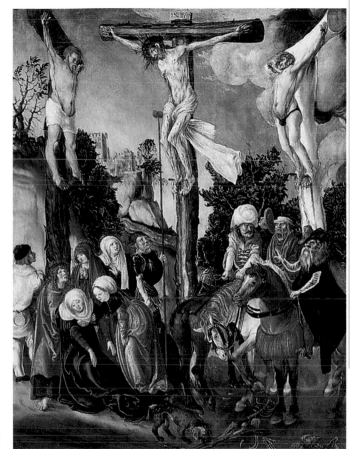

■ Matthias Grünewald, *Crucifixion*, 1512–16, Musée d'Unterlinden, Colmar. This is the main panel of one of the most disturbing polyptychs in German art.

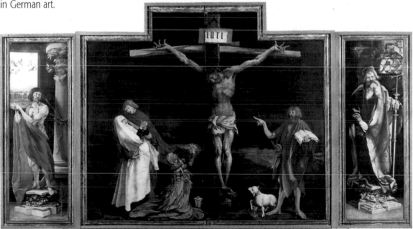

The admiration for intelligence and tranquillity

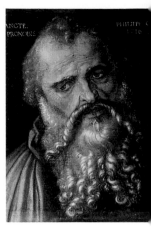

■ Dürer, *St Philip,* 1516, Galleria degli Uffizi, Florence. Like its companion work, in the photograph opposite, the apostle is painted with patient elegance and precision.

Concerned by the dramatic direction international events were taking and exasperated by the increasing conflicts that were taking place even in the cultured and refined city of Nuremberg, Dürer made a further, heartbroken appeal for moderation and reason. For an artist like him, who was searching for a "canon" of beauty and a scientific definition of proportions, all excesses and violence, even if only verbal, were totally unacceptable. Because of the conciliatory position he took, and his willingness to listen to all arguments without preconceived ideas, it has never been established whether Dürer supported the Reformation or remained a Catholic. Probably, like his friend Pirckheimer, he remained in a position of doubt, somewhere between the two. It is, however, certain that, although he strongly wished to do so, Dürer never met Luther after 1520.

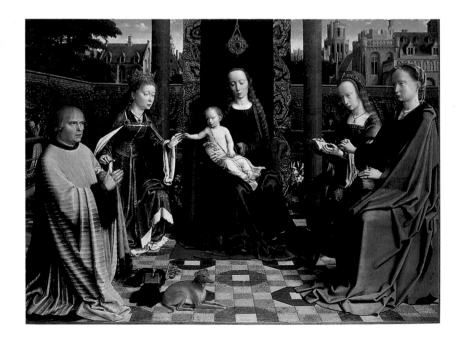

■ Dürer, *Madonna with the Carnation*, 1516, Alte Pinakothek, Munich. A curious atmosphere pervades this unusual Madonna. The Child clutches a pear, while the Virgin holds a delicate red carnation in her hand. The two figures do not look at one another and, indeed, the Madonna appears to be deep in thought and somehow far away. The perfect axial structure of the face and its "ideal" beauty, are reminiscent of Leonardo's precepts.

■ Dürer, *St James*, 1516, Galleria degli Uffizi, Florence. The apostles are among the most moving of Dürer's mature works. The disturbed expression of the saints has been interpreted as an omen of the imminent Reformation.

■ Gérard David, *The Virgin and Child with Saints and Donor*, c.1509, National Gallery, London. The clear luminosity, the tranquillity and composure of the scene, suggest a calm and profound discussion, along the lines of Erasmus' reasonings. Increasingly troubled by the growing animosity of religious debate, Dürer favored calm, restrained behavior.

MASTERPIECES

St Jerome in his Study

This engraving dates from 1514, arguably Dürer's finest year as an engraver. The chamber in which the saint is pictured writing is a masterpiece of perspective and light.

■ On the left wall, Dürer skilfully succeeds in showing the reflection of the light through the round glass panes of the windows.

■ The sleeping dog imparts an atmosphere of quiet domestic tranquillity to the scene, which not even the presence of the tame lion can disturb.

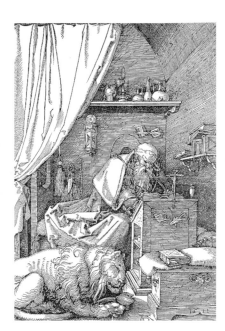

■ Antonello da Messina, *St Jerome in his Study*, c.1475, National Gallery, London. The figure of the literary saint is one of the best-loved by humanist painters, who made it the prototype of the scholar.

■ Dürer, *St Jerome in his Study*. In this further engraving, the artist has produced another version of the same subject, this time dominated by a large drawn curtain.

■ The man of letters with a pair of scissors and carefully folded sheets of parchment neatly stored behind his writing desk.

■ Vittore Carpaccio, *The Vision of St Augustine*, c.1502, Scuola di San Giorgio, Venice. Dürer was certainly inspired by this masterpiece of the Venetian Renaissance, made unforgettable by the mystical and poetic light which filters into the humanist's elegant and ordered study.

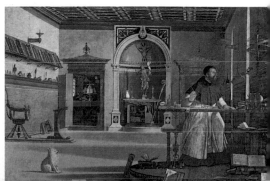

Albrecht Dürer, *Portrait of Jakob Muffel*, detail, 1526, Staatliche Museen, Berlin

Erasmus of Rotterdam
and Melanchthon

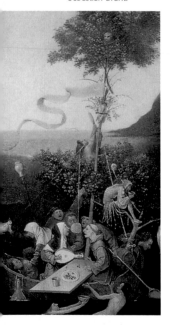

■ Bosch, *The Ship of Fools*, c.1500, Musée du Louvre, Paris. This painting took its inspiration from the moralizing book by the Dutchman Sebastian Brant.

Inspired by a strong religious belief, Dürer followed the Reformation movement with a keen interest. He was, undoubtedly, attracted by two figures who would eventually be on opposite sides of the argument, but who shared many features in common: Erasmus of Rotterdam and Melanchthon. Erasmus, a refined humanist, had denounced the evils of the Church before Luther: driven by a spirit of dialogue and moderation, he urged an internal reform of Catholicism. The meeting and exchange of opinions between Dürer and Erasmus is one of the high points in European culture. Philipp Melanchthon, an extraordinary child prodigy, already held three degrees at the age of 19, and taught Greek and Hebrew at the University of Wittenberg. Fascinated by Luther, he immediately allied himself with him. Melanchthon was the author of detailed studies of St Paul and, in 1521, of *Loci communes rerum theologicarum*, the main doctrinal text of the early years of the Reformation. Dürer made an objective and dispassionate study of the restrained and deeply thought-out arguments put forward by Erasmus and Melanchton, who, although on opposite sides of the doctrinal scale, were equally intelligent and cultured men.

■ Dürer, *Cardinal Albrecht of Brandenburg*, 1523. From his pulpit at the bishopric of Halle, the cardinal was the most resolute German opponent of the first Protestant wave.

■ Dürer, *Philipp Melanchthon*, 1526. In the inscription which accompanies this engraving Dürer observes: "I have been able to portray the face of Melanchthon but not the genius of his mind". Nevertheless, the portrait reveals a flash of penetrating intelligence. Dürer felt that Melanchthon had a truly magnetic, persuasive personality.

■ Dürer, *Erasmus of Rotterdam*, 1526. It is not by chance that Dürer portrayed both Melanchthon and the Dutch humanist in an engraving dating from the same year, stressing his admiration for both.

■ Tilam Riemenschneider, *St Burckhardt*, c.1520, National Gallery, Washington, D.C.. The sculptor's magnificent works in wood reveal a growing, penetrating melancholy .

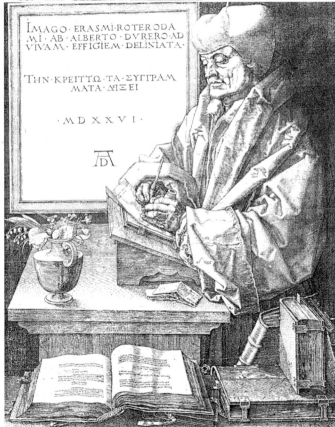

St Jerome in Meditation

Executed in 1521, this painting was taken to
Portugal by Ruy Fernandez de Almeida, the
young dignitary who had commissioned it. It is
now in Lisbon's Museu Nacional de Arte Antiga.

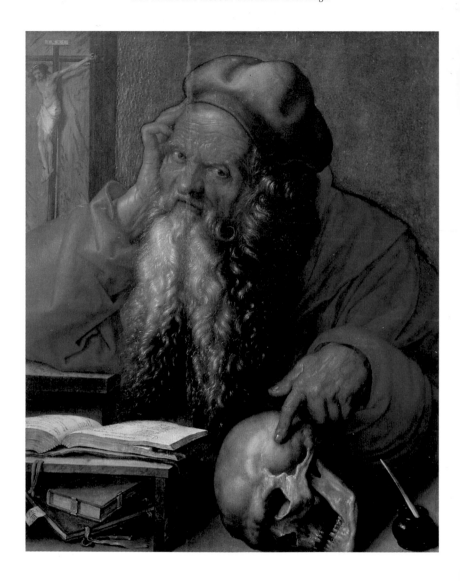

■ Dürer, *Study for the Head of St Jerome*, 1521, Albertina, Vienna. In Dürer's original idea, the saint appears engrossed in his reading. In the painting, on the other hand, he looks at us directly, involving us in his melancholy reflections on the destiny of man.

■ Bosch, *St John on Patmos*, c.1510, Museo Lazaro Galdiano, Madrid. The theme of solitary meditation, which Dürer took to the highest levels of psychological interpretation, is frequently seen in the art of a Europe which was troubled by moral and religious doubts.

■ Dürer, *Studies for the Skull, the Bookrest, and the Arm of St Jerome*, 1521, Albertina, Vienna. The preparatory drawings for this work are among the highest achievements of Dürer's draughtsmanship and may even be more effective than the finished works in terms of beauty and poetry. Early still life experiments illustrate Dürer's skill in enquiring into the character of objects.

105

The coronation of Charles V

Dürer's journey to the Low Countries was also an opportunity to secure influential contacts. In October 1520, having paid his respects to Margaret of Austria, regent of the Low Countries, he arrived in Aachen to attend a ceremony that was to have important consequences for the history of Europe: the coronation of Charles V, the most powerful ruler of the 16th century. The grandson of Maximilian, who had died in 1519, Charles of Hapsburg was only 20 years old when he inherited the reunified imperial crown of Austria and Spain. The magnificent ceremony took place on October 28, 1520 in the Palatine Chapel at Aachen, the symbol of the Holy Roman Empire, which had been built by Charlemagne. Dürer witnessed the ceremony in the company of Matthias Grünewald. Two weeks later he was presented to the emperor, who promised him the same economic privileges and tax exemptions his predecessor had granted him.

■ Dürer, *The Palatine Chapel at Aachen*, 1520, Albertina, Vienna. A detailed drawing of the historic ninth-century cathedral where the coronation of Charles V was held.

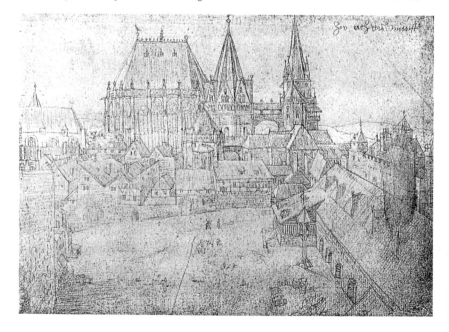

■ Portraits of Charles V began to appear everywhere, as in this enamelled hat pin with the motto "Plus Ultra".

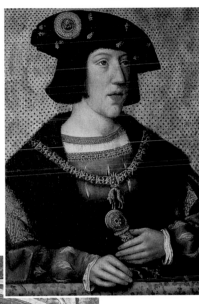

■ Charles V aged 20. Soon to become a powerful emperor, the young man adopts a look of astonishment, revealing his youth and humility.

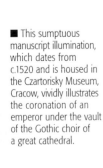

■ This sumptuous manuscript illumination, which dates from c.1520 and is housed in the Czartorisky Museum, Cracow, vividly illustrates the coronation of an emperor under the vault of the Gothic choir of a great cathedral.

The journey to Holland

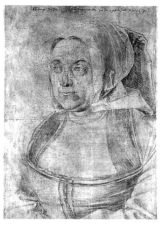

Dürer set off for the Low Countries on July 15, 1520. His destination was Antwerp, but the itinerary progressed slowly between celebrations, banquets, gatherings, official audiences in Bamberg, Frankfurt, and Mainz. This was the apotheosis for the 50-year-old master, dubbed the "pride of the nation". Dürer kept a diary throughout his journey, in which he recorded meetings, interesting events, expenses, historic episodes, and banal incidents. In Antwerp he met many important painters, and made excursions to Flanders and Holland. Among the artists who were most ready to interpret Dürer's innovative ideas were Jan Gossaert, Quentin Metsys, and, most of all, Lucas von Leyden, who also executed splendid engravings. The journey ended unpleasantly, however: during the winter Dürer tried to see a whale beached on the coast but was caught in a dreadful storm. The master fell ill and found it difficult to recover.

■ Dürer, *Agnes*, 1521, Kupferstichkabinett, Berlin. For the first time, Dürer travelled abroad accompanied by his wife.

■ Dürer, *Lazarus Ravensburger*, 1520, Kupferstichkabinett, Berlin. The tower in the background is from a late-Gothic building in Antwerp.

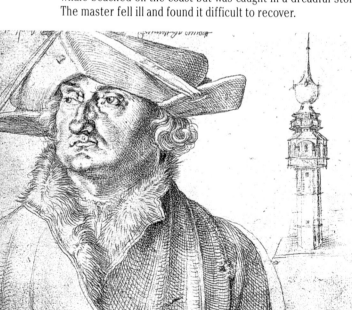

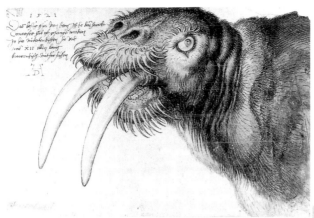

■ Dürer, *Head of a Walrus*, 1521, British Museum, London. This is the first "portrait" of a walrus in European art. In order to draw animals like this, Dürer endured considerable physical discomforts which finally threatened his health.

■ Dürer (attributed), *Lion in Profile*, 1521, Albertina, Vienna. This may be a copy: Dürer's lion drawings were very famous and widely imitated.

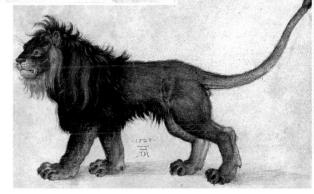

■ Dürer, *Caspar Sturm Before a River Landscape*, 1520, Musée Condé, Chantilly. The portraits Dürer drew in Antwerp have the same freshness and immediacy found in the pages of his travel journal.

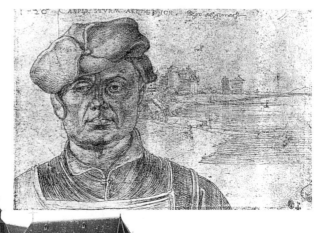

■ The side of Antwerp Cathedral is dominated by the spire built by Rombout Keldermans.

Pupils, imitators, and followers

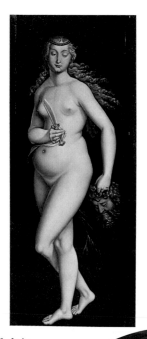

\mathbf{T}he journey to Flanders and Holland stressed the consummately international nature of Dürer's art. Although it remains the highest and most typical expression of the Renaissance in Germany or, more accurately, in Nuremberg, Dürer's work is a phenomenon which involves the whole of Europe, to such an extent that it is difficult to define a precise boundary between pupils, collaborators, and artists who continued his tradition. Dürer's influence undoubtedly spread way beyond his workshop. Thanks to his journeys and engravings, Dürer's compositions were studied throughout Europe. The point at which his influence was at its greatest can be dated at around 1520. It is interesting to note that in Germany and Flanders Dürer was viewed as a great interpreter of humanism and italianizing classicism, whereas in Italy his engravings conveyed a typically northern expression. The importance of this apparent contradiction should not be underestimated; on the contrary, it is proof of Dürer's open and international spirit within the heart of the European Renaissance.

■ Jacopo Pontormo, *Christ Before Pilate*, 1523–25, Certosa del Galluzzo, Florence. To the astonishment and hostility of his fellow Florentines, Pontormo rated Dürer's prints among the best models of the new developments of Renaissance art in Europe, next to Raphael and Michelangelo. The frescos in the Galluzzo, sadly in a poor state of repair, are a clamorous tribute to the great German master.

■ Hans Baldung Grien, *Judith with the Head of Holofernes*, 1525, Germanisches Museum, Nuremberg. The nude heroine may be compared with Dürer's Lucretia (see p. 94).

■ Hans Schäuffelein, *Adoration of the Magi*, c.1515, Staatsgalerie, Stuttgart. The face of the second king, who is wearing a fur hat, is a tribute to Dürer, the undisputed head of German art.

■ Lucas von Leyden, *Madonna and Child with Six Angels*, c.1520, Staatliche Museen, Berlin. Dürer admired the Dutch artist's work, which combined the northern tradition with Italian novelties.

■ Gaudenzio Ferrari, *The Arrest of Christ*, 1513, Santa Maria delle Grazie, Varallo (Vercelli). Ferrari was quick to interpret ideas he had borrowed from Dürer with a great sweep of theatricality. The scenes from the *Passion of Christ*, painted in Varallo, are an eloquent example of this. Among Italian artists, Lorenzo Lotto also drew on the *Life of the Virgin* and the two *Passion* series by Dürer.

The Reformation

BACKGROUND

■ Lucas Cranach the Elder, *Martin Luther*, 1529, Galleria degli Uffizi, Florence. Cranach painted several portraits of Luther and Melanchthon, to make them known.

■ *Adam and Eve*, engraving by Cranach the Elder for the edition of the Bible translated into German by Luther and funded by the Elector of Saxony (1546).

■ Dürer, *Sudarium Displayed by Two Angels*, 1503. The artist's religious feeling was strong and committed.

In 1520, refusing to retract any of his words after the failure of the Diet of Augsburg, Luther published three treatises, intended mainly for the German nobility: he denied the authority of the pope, denounced the simoniac sale of indulgences, and stated that Christians could only be saved by means of divine Grace. Pope Leo X, the son of Lorenzo the Magnificent, who had considered Luther's protests a mere monks' quarrel could no longer avoid taking grave steps. On July 2, 1520 he excommunicated Luther, who in response publicly burned the papal bull (December 10, 1520). The newly created emperor Charles V had to intervene and, with the Diet of Worms (1521), the controversy over the Reformation added a political dimension to the religious debate. Luther was pronounced a heretic and was about to be captured and burned at the stake when Frederick of Saxony entered the fray, taking Luther under his wing and leading him to safety. In the haven of Wartburg Castle Luther undertook the translation of the Bible into German. Meanwhile, the wave of freedom began to transform itself into a dangerous hymn to anarchy. Franz von Sickingen organized a group of brigand knights to fight the middle classes and the nobility. The revolt was quashed with bloodshed in 1523.

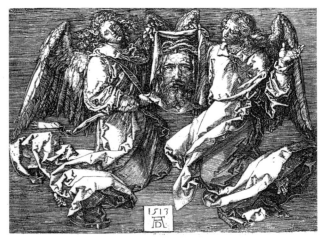

■ In this colored engraving, dating from 1557. Luther, still wearing his Augustinian habit, refuses to submit to the authority of the Church. This episode, which was followed by the Diet of Augsburg, marked the official beginning of the Protestant Schism. In 1520, the pope excommunicated Luther with the "Exurge Domine" Bull of Condemnation.

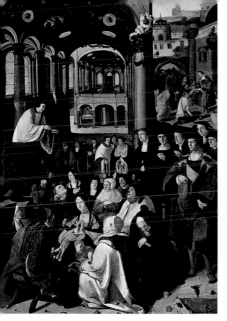

■ This painting by Lucas von Leyden, dated 1530, and housed at the Rijksmuseum, Amsterdam, illustrates how preachers were fundamental in spreading the message of the Reformation.

■ The stout but elegant John Frederick, Elector of Saxony, who succeeded Frederick the Wise, is shown protecting Luther and Melanchthon.

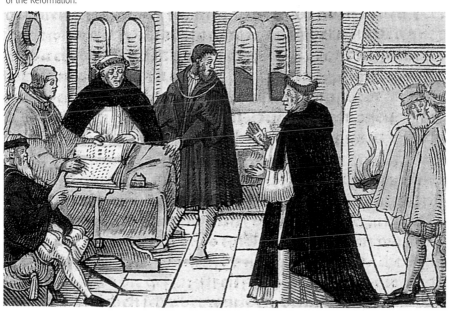

The peasant revolt

One of the tragedies in German history is the revolt of Thomas Müntzer's Anabaptists. Recruiting followers from among the humblest classes, Müntzer assembled an army which attacked the troops of the nobility at Frankenhausen on May 15, 1525. It was a massacre: 10,000 peasants fell. Luther saluted the action, calling Müntzer's followers "rabid dogs" to be put down. Dürer, however, was deeply concerned by the wave of iconoclasm aroused by the Sacramentarians' movement: their violent action, besides leading to the murder of members of the clergy and the looting of churches, provoked the destruction of works of art. Luther finally condemned the peasants. More successful was the combined action of the Lutheran princes, which led to the secularization of large areas of Germany, the closure of convents, and the locking up of ecclesiastical treasures. In 1526 Luther published his *Cathechism*: the Reformation was now established throughout most of the country.

■ The magnificent Catholic cathedral of Mainz, the primatial seat of Germany, is one of the most flawless masterpieces of German Romanesque architecture. It is not far from the Rhine. It was in the Rhineland that most of the bloodiest military action and looting took place in the early years of the Reformation. The Rhineland was also where the main Diets were held, such as those of Worms and Spires.

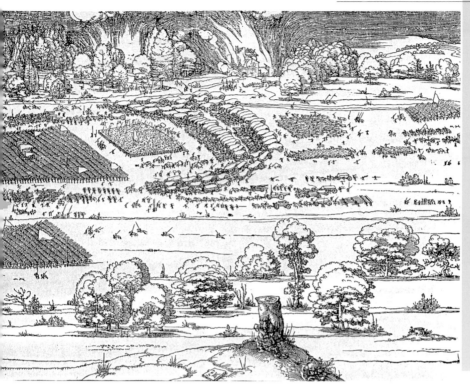

■ Dürer devised this celebratory monument to mark the end of the peasant revolt. Farm animals form the basis of a totem made up of agricultural objects and implements. At the top there is a farmer with a dagger in his back.

■ Dürer, *Troops Moving Across the Plain*, 1527. The engraving is included in the treatise on fortifications written by Dürer in the wake of the uncontrollable wave of bloody civil wars in Germany.

■ Dürer, *The Bagpiper*, 1514. As this engraving shows, Dürer looked down on peasants with a certain aristocratic detachment.

1520-1528

The attitude of an intellectual aristocrat

A surfeit of controversy, violence, iconoclasm and, most of all, the raging of bloody revolts (minor aristocrats, weavers, Anabaptists, peasants) made Dürer bitter and he longed for a return to peaceful dialogue in which intelligence could prevail over virulence and coarseness. As an intellectual, Dürer insisted in his appeals for moderation, balance, and the need to listen to both sides of the argument; the letters to his friend Willibald Pirckheimer and the inscription on the base of the *Four Apostles* make this clear. Dürer must certainly have been affected by Pirckheimer's choices: the humanist had at first supported the Reformation but, after Luther's aggression and the extreme behavior of the Protestants, he subsequently returned to Catholicism. Dürer was not the only intellectual to be disaffected: in Italy Lorenzo Lotto was also beset by a personal crisis and, even more so, Michelangelo.

■ Dürer, *Cupid Stung by the Bees*, Albertina, Vienna. With extreme delicacy, Dürer interprets the myth of Cupid, who, greedy for honey, is stung by bees near a hive. Venus reminds us of the meaning of the fable, warning against the dangers of being carried away by voluptuous desire. The snare of love was no metaphor: in Dürer's time Europe was undergoing its first, rampant syphilis epidemic.

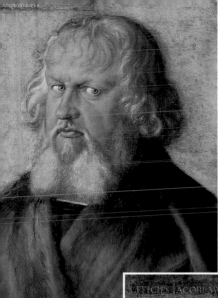

■ Dürer, *Portrait of Hieronymus Holzschuer*, 1526, Staatliche Museen, Berlin. The portrait of the Nuremberg town councillor is linked to that of the burgomaster Muffel (below). They may have been painted to mark an official occasion. The two portraits are evidence of Dürer's lucidity of vision in his later years. Although the likeness is perfectly drawn in both cases, the figures are treated with an almost caricatured expressiveness emphasised by their rigidity and the dramatic lighting.

■ Dürer, *Portrait of Jakob Muffel*, 1526, Staatliche Museen, Berlin. Muffel was burgomaster of Nuremberg when Dürer presented the city with *The Four Apostles*. As in the portrait of Holzschuer, Dürer has used an even blue background. He examines the sitter's features and feelings with a penetrating elegance, and renders with dramatic immediacy the pensive intelligence and solitary thoughtfulness of the eminent politician.

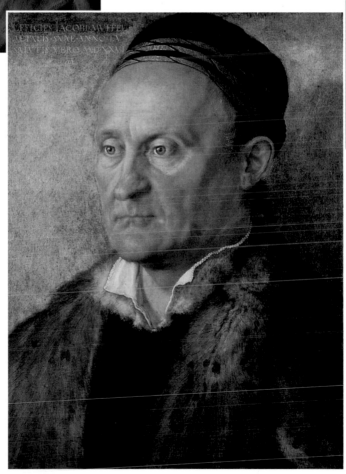

117

1520-1528

Portrait of Johannes Kelberger

Housed in Vienna, this may be the last portrait Dürer painted. The sitter, a wealthy occultist, married Felicita Pirckheimer, Willibald's daughter, in 1528 only to leave her soon after and emigrate to France.

■ Tondo portraits date from the Roman numismatic tradition. During the Renaissance this legacy was splendidly revived in Pisanello's medallions.

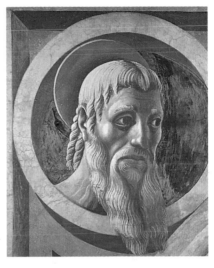

■ Botticelli, *Giuliano de' Medici*, Accademia Carrara, Bergamo. The frame around the face provides an even space within which the nobleman is painted with a sharp linearity.

■ Paolo Uccello, *A Prophet*, c.1440, Santa Maria Novella, Florence. Four bearded figures peer out of the tondos around the clock, painted by Paolo Uccello, on the inner facade of the Florentine cathedral.

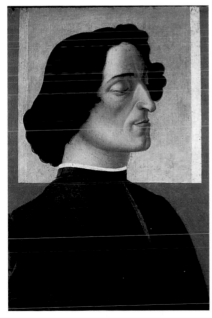

■ Parmigianino, *Self-portrait*, Kunsthistorisches Museum, Vienna. Working at the same time as Dürer, the Italian artist fully exploited the difficult tondo format with supreme skill, cleverly showing his own image deformed within a convex mirror.

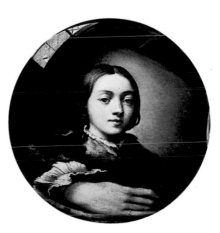

119

The theory of the "four humors"

For decades Dürer studied and illustrated the most widespread theory of late-medieval medicine: the "four humors". According to this, four elemental fluids flowed through the human body: blood, phlegm, yellow bile, and black bile. The balance between these fluids determined physical health, and an excess of any one of them predisposed to illness. A series of consequences was connected to the theory of the "four humors": hot and cold, damp and dry, the influence of stars and constellations, temperament, and psychology. Dürer believed he was a melancholy temperament, dominated by the planet Saturn. The ailments and diseases from which he suffered were, according to his thinking, due to an uncontrolled surfeit of black bile in his body. Totally satisfied by this traditional theory, Dürer felt no need to deepen his enquiries into the field of medicine, or to dissect bodies or perform other macabre experiments like some other figures of his time such as Leonardo. The artist maintained this respect towards traditional medicine even in his later years, when he became aware of the major changes occurring in the world, and he occupied himself in the writing of treatises, some of which remained unfinished.

■ Leonardo da Vinci, *Anatomy of the Human Skull*, Royal Collection, Windsor. Leonardo's drawings are the first scientific studies of the human body.

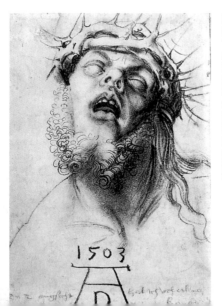

■ Dürer, *Christ Crowned with Thorns*, 1503. This extraordinary drawing, an agonized image, dates from the period in which the artist's hypochondria was at its most acute. He was convinced he was in the psychopathological state of melancholia, which led him to identify with the sufferings of Christ.

■ Johann Stephan Calcar, *Human Skull*, 1540. The illustrations for the first modern treatise on anatomy, written in Padua by Andrea Vesalio, were drawn by Calcar in Titian's Venetian workshop.

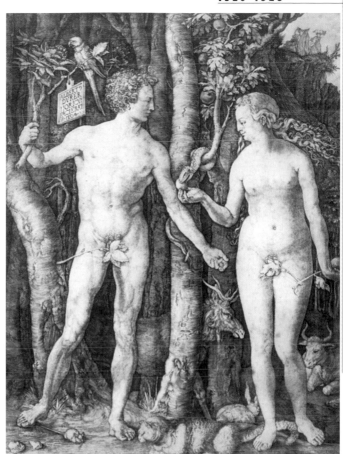

■ Dürer, *Adam and Eve*, 1504. Even the animals in the Garden of Eden symbolize the four temperaments: the bull is phlegmatic, the stag melancholic, the rabbit sanguine, and the cat, ready to pounce on the mouse, is choleric.

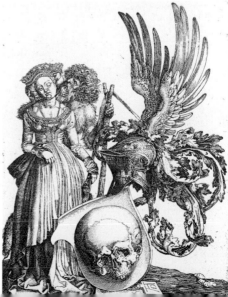

1520-1528

The Four Apostles

Presented by Dürer to the city of Nuremberg in 1526 and now in the Alte Pinakothek, Munich, the two panels represent the artist's spiritual testament.

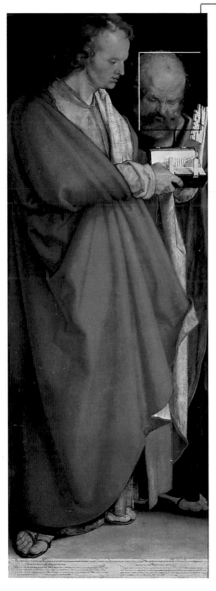
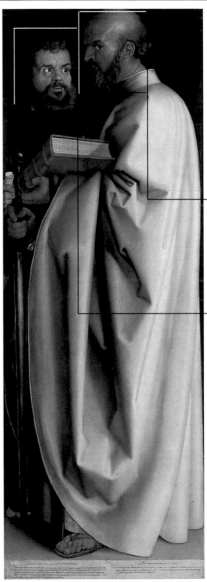

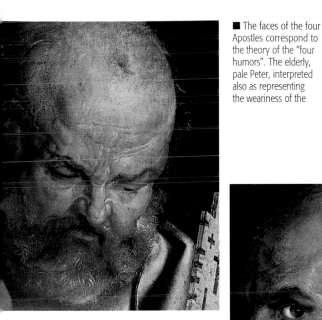

■ The faces of the four Apostles correspond to the theory of the "four humors". The elderly, pale Peter, interpreted also as representing the weariness of the Primate of Rome, is the expression of the phlegmatic temperament. Alongside him, fiery and flushed, is John, who displays typically sanguine features.

■ The sombre and noble Paul, solitary and introverted, symbolizes melancholy, the physical and mental state with which Dürer identified. Although divided by their respective "humors", the four saints all express an exemplary harmony of intent in the early and tumultous years of the Reformation.

■ The agitated Mark is portrayed by Dürer in the unusual gesture of grinding his teeth, a typical feature of the choleric. The lengthy inscription below, written by an expert calligrapher, denounces excess and violence.

The treatises

■ Frontispiece to the first edition of the treatise on proportions, with Dürer's distinctive AD monogram.

In his final years Dürer concentrated on treatises and writings, which form the main literary body of any German artist up to the 18th century. Prepared over a long time, illustrated with engravings which reveal an enviable didactic clarity, three volumes in succession were printed in Nuremberg. In 1525 Dürer published a treatise on geometry in German (*Unterwesung der Messung*). In 1527, also in German, he produced

a text on fortifications and building walls capable of withstanding firearms (*Unterricht zu Befestigung*). Finally, his great treatise on symmetry and the proportions of the human body (*De symmetria partium*) was published posthumously, in Latin and German, in 1528. Dürer's major theoretical work, a vast treatise on art, remained unfinished. Of this text, which may never have reached a concrete stage, only drawings and scattered notes survive.

■ On the left, an instrument devised by Dürer for rendering perspective. For years the master collected ideas, drawings, and observations for such a treatise, which never saw the light of day.

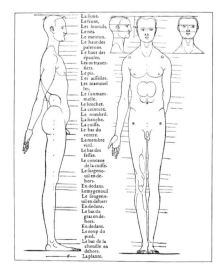

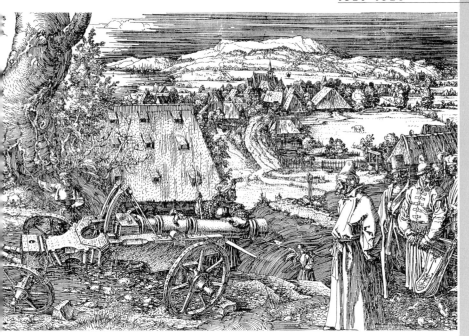

■ Illustrations for the treatise on proportions, with the detailed "ideal" measurements of human bodies of varying ages and types.

■ Dürer, *Landscape with Cannon*, 1518. This engraving, produced at the time when the threat of war loomed over Germany, shows the artist's interest in the development of firearms and military science, which culminated in his treatise on fortifications.

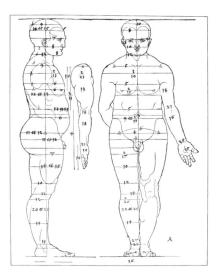

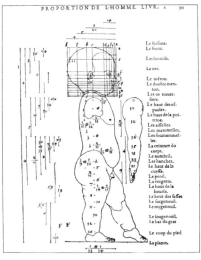

LIFE AND WORKS

The ideal of a perfect beauty

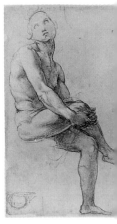

■ Raphael, *Study for a Seated Youth*, 1504, Gabinetti dei disegni degli Uffizi, Florence. Raphael, too, sought to find the perfect harmony between regular rules and nature in the early 1500s.

Towards the end of his life Dürer narrowed his painterly output, and increasingly sought to understand the changing times. He tried to detach himself from the tumultuous, dramatic events of his day in order to reflect on the great historical events, and the psychological, social, and

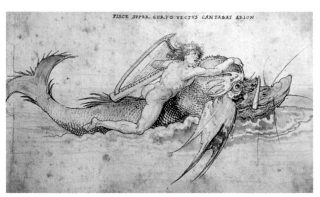

■ Dürer, *Arion on the Dolphin*, Albertina, Vienna. The inscription in Greek and the reference to the ancient myth give this drawing an aura of intense classicism. Dürer is comparing the harmony of the male nude with the large marine monster, in a poetic contrast between beauty and ugliness.

religious changes he had witnessed in his lifetime. An awareness, which had lain dormant for years, of the limitations of art, the contrast between the utopian visions of humanism and reality, crystallized to a certainty. Dürer continued to search for a mathematical canon which would describe and set out rules for beauty, but it constantly eluded him. Meanwhile, the myth of man as the architect of his own history, was crumbling under the pressure of the Protestant Schism and the bloodbath of the religious wars. His final masterpieces suggest he was anxious to hand down a trace of himself to posterity but also hint at his awareness of having failed in some of the ideals to which he had devoted his life.

■ Tilman Riemenschneider, *St Barbara*, c.1515, Bayerisches Museum, Munich. In this appealing wood figure, the sculptor carves out a delicate, romantic model of beauty.

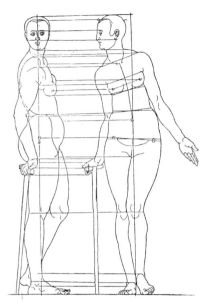

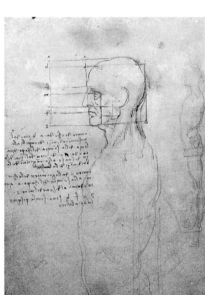

■ Dürer, *Proportions of the Human Body*. In the didactic illustrations to his treatise, human figures appear as rigid and mechanical as manikins.

■ Dürer, *Rear View of a Female Nude Holding a Cap*, 1506, Kupferstichkabinett, Berlin. When he is not looking for scientific demonstrations, Dürer can capture beauty with great spontaneity.

■ Even Leonardo da Vinci ,as this annotated drawing shows, was for a long time engaged in the pursuit of a canon that would determine the classical rule for beauty.

The Renaissance, a season briefly interrupted

Among the most manifest effects of the Reformation was the sudden ban on sacred paintings. By forbidding the cult of devotional images, Luther provoked a move against altar pictures, possibly beyond his intentions. Dürer tried to impress his own authority on the matter, arguing the case for art, and stating that a work executed with intricacy and care was effectively a hymn to God. Even the most heartfelt appeals were doomed to fail, however. After 1530, no further altarpieces or wooden altars were produced in Germany. Dürer also slowed down his output during the last years of his life. The German Renaissance was interrupted, in order to resume after a few decades, in a new guise which was elaborate, precious, and aristocratic, thanks to the capricious collecting habits of late 16th-century princes. The same went for the applied arts: Nuremberg modified its traditional production of goldwork and scientific instruments and instigated an elegant production of ornamental clocks. Augsburg, keen to take over Nuremberg's lead in the market, put up progressively fiercer competition, particularly as far as the production of luxury objects in silver and ebony was concerned. Nuremberg's supremacy thus came under threat.

■ Hans Holbein the Younger, *Henry VIII*, 1536, Thyssen Collection, Madrid. Because of the Reformation, Holbein left Germany for England.

■ Savoldo, *The Penitent St Jerome*, c.1525, National Gallery, London. The direct expression of reality, championed by Dürer, found enthusiastic followers among the Lombard painters.

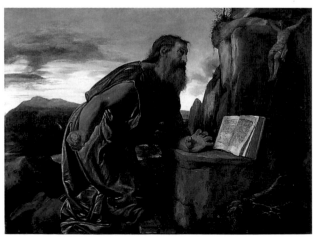

■ With Dürer, the printing of art gained a decisive impetus.

■ Cranach the Elder, *The Nymph of the Fountain*, 1518, Museum der Bildenden Künste, Leipzig. Despite the ample landscape and the classical allusion, Cranach clings to traditional draughtsmanship.

■ Dürer, *The Nymph of the Spring*, c.1515, Albertina, Vienna. This painting shows a longing for the ancient world.

■ Giorgione and Titian, *The Sleeping Venus*, 1510, Gemäldegalerie, Dresden. A perfect balance between idealized beauty, a sincere feeling for nature, and the application of the rules set out in the art of antiquity found its full expression in High-Renaissance Italian art.

Death and legacy

Having completed the *Four Apostles* and his treatise on human proportions, Dürer was now nearly 57 years old. He was still relatively young, but his health, particularly after his return from the journey through the Low Countries, was poor. No one, however, could have foreseen the illness which struck the master in the spring of 1528: Dürer died on April 6. He was buried in the Johannes Friedhof in Nuremberg, and his grave is still visible today. The Latin inscription on his tombstone (written in classical capital letters and not in Gothic script) came from Pirckheimer. It read, "that which was mortal in Albrecht Dürer lies buried in this tomb." A few days after burial, the painter's body was exhumed so that a death mask could be made. Pirckheimer's words were soon proved wrong: The Reformation almost completely stifled sacred art in Germany, provoking among other things the departure of some artists for other countries, while the prolonged religious wars between the Teutonic princes and Charles V, which only came to an end in 1550 with the peace of Augsburg, seriously impoverished the economy. Dürer's legacy was soon exhausted. The master remained a myth in German art, but his message as painter was only rediscovered in the 20th century, becoming a fundamental source of the figurative expressionism at work between the wars.

■ Dürer (attributed), *The Road to Calvary*, 1527, Accademia Carrara, Bergamo. Possibly an old copy of a lost original, this is painted with an elegant use of chiaroscuro which vies with the light effects Dürer achieved in his engravings.

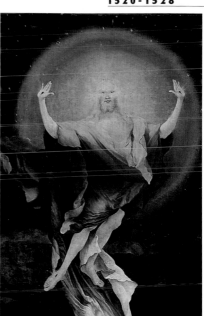

■ Matthias Grünewald, *Christ's Resurrection*, c.1519, Musée d'Unterlinden, Colmar. The fantastical, radiant, transfigured image of the Risen Christ recalls the stylistic features typical of Dürer.

■ Leonardo da Vinci, *Deluge*, c.1516, Royal Collection, Windsor. Just like Dürer, Leonardo also imagined the world overwhelmed by a whirlwind of water during the last years of his life.

■ Dürer, *Nightmare*, 1525, Albertina, Vienna. As the inscription explains, three years before his death Dürer had a premonitory dream about a fearful deluge and a cyclone which engulfed the earth. His affinity with Leonardo's final visions is remarkable.

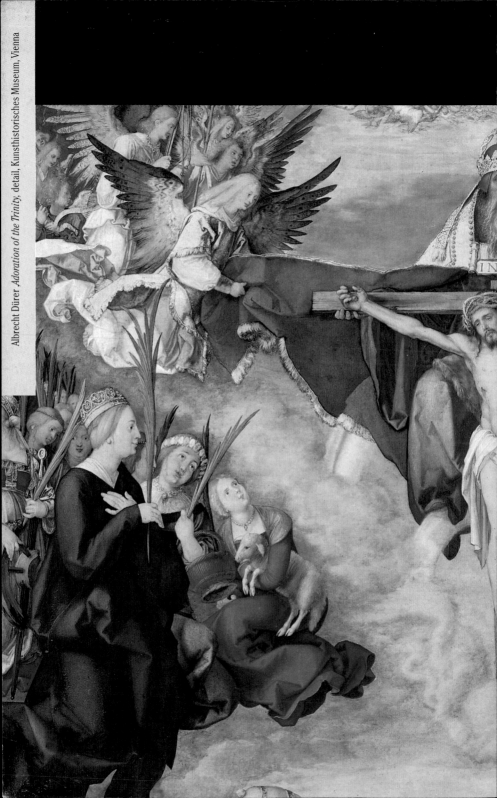

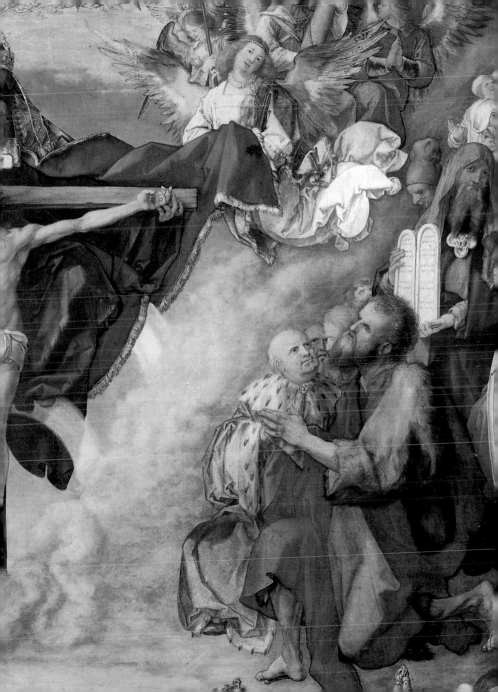

Note

*The places listed in this section refer to the current location of Dürer's works. Where more than one work is housed in the same **place**, they are listed in chronological order.*

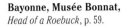

■ Dürer, *The Annunciation*, 1503-04, Kupferstichkabinett, Berlin.

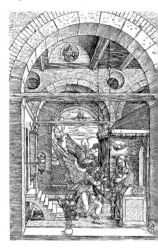

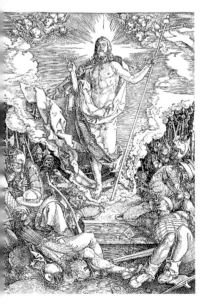

■ Dürer, *The Resurrection of Christ*, 1510, Kupferstichkabinett, Berlin.

■ Dürer, *View of Kalchreut*, 1511, formerly Kunsthalle, Bremen.

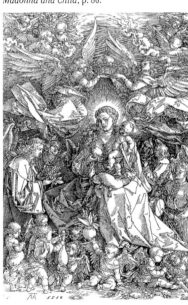

■ Dürer, *Mary Queen of Angels*, 1518, Kupferstichkabinett, Berlin.

■ Dürer, *Wire-Drawing Mill*, 1489–90, Kupferstichkabinett, Berlin.

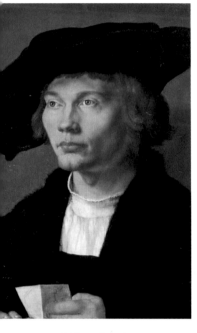

■ Dürer, *Portrait of Bernhard von Reesen*, 1521, Gemäldegalerie, Dresden.

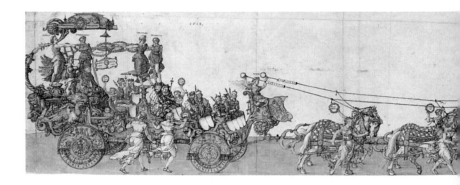

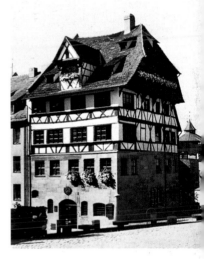

■ Dürer, The Dürerhaus in Nuremberg, dating from c.1450.

■ Dürer, *The Triumphal Chariot of Maximilian I*, 1518, Albertina, Vienna.

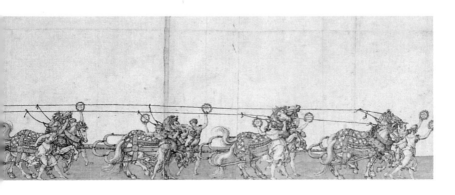

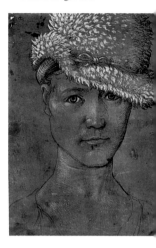

Note

*All the names mentioned
here are artists, intellectuals,
politicians, and businessmen
who had some connection
with Dürer, as well as painters,
sculptors, and architects who
were contemporaries or active
in the same places as Dürer.*

Alexander VI Borgia
(1492–1503), Spanish by birth,
this capable and ambitious
politician was portrayed by Dürer
in *The Feast of the Rose Garlands*,
the altarpiece executed for the
church of San Bartolomeo
di Rialto, p. 51.

Altdorfer, Albrecht (c.1480–
Regensburg 1538), painter. He
was the main exponent of the
Danube School, meeting Dürer
at the Viennese court,
pp. 72, 78, 79, 94.

Andreae, Hieronymus,
engraver. He collaborated with
Dürer and Johannes Stabius on
the *Triumphal Arch* and the
Procession, enormous series of
prints ordered by Maximilian
of Hapsburg, p. 68.

Baldung, Grien Hans
(Schwäbig Gmünd 1484/85–1545),
painter from Strasbourg and
friend of Dürer, pp. 16, 94, 111.

Bartolomeo, Veneto
(first half of the 16th century),
painter active in the Veneto and in
Lombardy. As a portraitist he was
heavily influenced by Dürer, p. 48.

Bellini, Giovanni (Venice
c.1432–1516), son of Jacopo,
brother of Gentile, and the official

painter to the Most Serene
Republic of Venice from 1483.
His work was admired by Dürer while
he was in Venice, pp. 20, 21, 31, 88.

Bianca, Maria Sforza (Milan
1472–Innsbruck 1510), the niece of
Ludovico il Moro and second wife
of Maximilian I of Hapsburg, p. 72.

Bosch, Hieronymus, real name
Jeroen Anthoniszoonvan Aeken
(s'Hertogenbosch c.1450–1516),
extraordinarily inventive Flemish
painter. He painted with often
bold and complex symbolism.
He probably met Dürer in Italy,
pp. 57, 60, 102, 105.

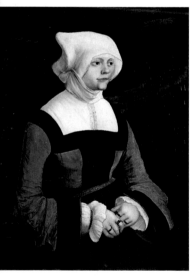

■ Albrecht Altdorfer,
*Portrait of a Young
Woman*, c.1515, Thyssen
Collection, Madrid.

■ Hieronymus Bosch,
Presumed self-portrait,
detail from the *Triptych of
the Temptations*, 1505-06,
Museu Nacionall de Arte
Antiga, Lisbon.

Brant, Sebastian, Dutch
writer and author of the famous
book, *The Ship of Fools*. Dürer
illustrated part of this in a
luxurious edition, p. 23.

Celtis, Konrad (Würzburg
1459–Vienna 1508), the first
German to be crowned poet
laureate by Emperor Frederick
III. After much travelling he
settled in Vienna, flattered by
the regard in which Maximilian I
held his work. Dürer portrayed
himself next to him in
the *Martyrdom of the
Ten Thousand*, pp. 72, 73.

Charles V (1500–1558),
grandson of Maximilian I.
Emperor from 1529, he
inherited the Spanish crown
from his mother, Joan the Mad
and the Hapsburg dominions
from his father, Philip the
Handsome. Dürer attended
his coronation and was granted
the same economic privileges
he had enjoyed under
Charles's predecessor.

■ Lucas Cranach the
Younger, *Portrait of
Lucas Cranach the Elder*,
1550, Galleria degli
Uffizi, Florence.

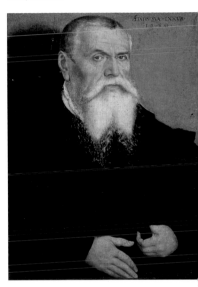

Cranach, Lucas the Elder
(Kronach 1472–Weimar 1553),
famous painter and engraver. As
the head of a thriving workshop,
he was an innovator in the
compositional structure of
painted works, chiefly religious
ones, pp. 54, 72, 94, 95, 112, 129.

De' Barbari, Jacopo (Venice
c.1440–c.1515), painter and
engraver. Active for many years
in Germany and Flanders, he
arranged the meeting between
Dürer and Luca Pacioli, p. 46.

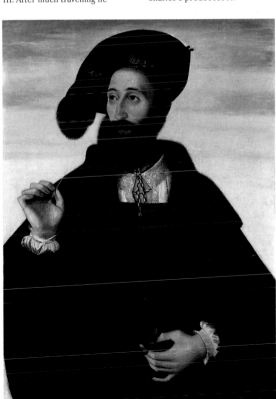

■ Bartolomeo Veneto ,
Portrait of a Patrician,
first half of the 16th
century, Thyssen
Collection, Madrid.

Dürer, Albrecht the Elder
(born 1420), father of Albrecht.
Of Hungarian origin, he moved to
Nuremberg where he married
and was a successful gold and
silversmith, pp. 8, 9.

Dürer, Hans, one of
Albrecht's 18 siblings. He worked
in the family workshop under
Albrecht after their father's
death, p. 42.

Erasmus of Rotterdam (1466
or 1469–1536), Dutch humanist.
He predicted an internal reform
of Catholicism, in some ways
anticipating Luther, from whom,
however, he distanced himself,
pp. 102, 103, 114.

Ertzlaub, Erhard, astronomer
at the court of Maximilian I. He
helped Dürer to produce two
engravings showing the map of
the world and the constellation of
the northern hemisphere, p. 72.

Frederick of Saxony, known as
The Wise, German Elector and
admirer and patron of Dürer. He
gave Luther a refuge in the castle
of Wartburg, pp. 26, 84, 112, 114.

Frey, Agnes, married Dürer in
1494. The couple had no children,
pp. 18, 86, 87.

Frey, Hans, Nuremberg
goldsmith and Dürer's father
-in-law, p. 18.

Fugger, a well-known family of
German bankers of modest
merchant origins, p. 84.

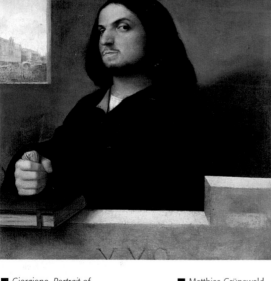

■ Giorgione, *Portrait of
a young Venetian*,
c.1505, National Gallery
of Art, Washington, D.C.

■ Matthias Grünewald,
*Madonna and Child
in a Landscape*, c.1520,
Catholic Parish
Church, Stuppach.

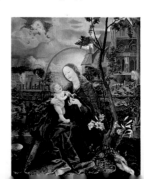

■ Jacopo de' Barbari, *Partridges and Armament*, 1504, Alte Pinakothek, Munich.

■ Hans Holbein the Elder, *Portrait of a Woman*, c.1512, Kunstmuseum, Basle.

German painter and contemporary of Dürer. He lived for a long time in Mainz in the service of Archbishop Albert of Brandenburg, pp. 96, 106, 131.

Holbein, Hans the Elder (Augsburg before 1470–Isenheim 1524), painter of famous altarpieces. He surpassed medieval themes and forms in order to create a style which seems occasionally to reveal the use of northern Italian models, p. 16.

Holper, Barbara (died 1514), married Albrecht Dürer the Elder. The third of their 18 children was the painter Albrecht, pp. 8, 42, 80.

Holper, Hieronymus, Nuremberg gold- and silversmith. His daughter Barbara married Albrecht Dürer the Elder, p. 8.

Holzschuer, Hieronymus, Nuremberg town councillor. Portrayed by Dürer in 1526, probably for an official occasion, p. 117.

Johannes, Stabius, architect. He collaborated with Dürer and Hieronymus Andreae on the artistic direction of *Triumphal Arch* and the *Procession*, p. 68.

Fugger, Jakob, Augsburg banker and the head of the German community in Venice, pp. 51, 84.

Gerolamo, Tedesco, architect. He planned the reconstruction of the Fondaco dei Tedeschi, rebuilt after a fire in 1505 and frescoed by Giorgione and Titian, among other artists.

Giorgione, real name Zorzi (or Giorgio) da Castelfranco (Castelfranco Veneto 1477/78–Venice 1510), painter. He introduced many innovations to Venetian painting. Dürer admired his work. He frescoed the Fondaco dei Tedeschi with Titian, pp. 21, 34, 44, 48, 52, 53, 92, 129.

Grünewald, Matthias, real name Neithardt Gothardt, (Würzburg c.1480–Halle 1528),

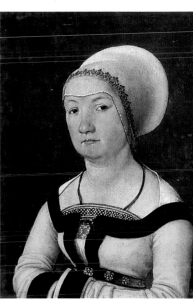

Kelberger, Johannes, wealthy Nuremberg occultist. He married Felicita, Willibald Pirckheimer's favorite daughter in 1528. Dürer dedicated his last portrait to him, p. 118.

■ Hans Holbein the Younger, *Portrait of Erasmus of Rotterdam*, 1523, Musée du Louvre, Paris.

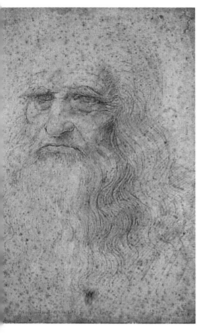

■ Leonardo, *Self-portrait*, Biblioteca Reale, Turin.

Koberger, Anton, Nuremberg's leading printer and publisher. He was also Dürer's godfather, p. 11.

Leonardo da Vinci (Vinci, Florence 1452–Amboise 1519), painter, sculptor, architect, engineer, and writer. He regarded scientific study as complementary to artistic work. His paintings and, part of his studies reveal such

close affinities with Dürer, pp. 43, 46, 52, 60, 61, 120, 124, 130.

Lucas van Leyden (1484/94–1533), Dutch painter and engraver whose work was much admired by Dürer, pp. 111, 113.

Luther, Martin (1483–1546), German religious reformer and instigator of the Protestant Reformation, pp. 84, 96, 112, 113, 114, 128.

Mantegna, Andrea (Isola di Carturo, Padua 1431–Mantua 1506), painter and engraver. He produced highly dramatic works which had a significant influence on his contemporaries and artists of successive generations for the particular way in which the figures are modelled and the emphasis on the chromatic and plastic effects. His popular and widely imitated engravings are considered to be among the masterpieces of Renaissance draughtsmanship, p. 20.

Maximilian I of Hapsburg (1458–1519), emperor from 1508. He founded the University of Vienna and surrounded himself with artists and intellectuals, from whom he commissioned important studies and works, pp. 51, 68, 70, 71, 72, 74, 75, 78, 84, 88.

Melanchthon, Philipp, Greek form of Philipp Schwarzerd (1497–1560), German humanist, reformer, and follower of Luther. He was known as *praeceptor Germaniae*, pp. 102, 103, 113.

Muffel, Jakob, Nuremberg burgomaster, portrayed by Dürer in 1526, pp. 100-01, 117.

Müntzer, Thomas (c.1476–1525), Augustinian monk. He supported the Protestant Reformation, soon moving to a

■ Pontormo, *Portrait of a Lady in Red*, 1532-33, Städelsches Kunstinstitut, Frankfurt.

■ Andrea Mantegna,
The Dead Christ,
Pinacoteca di
Brera, Milan.

■ Titian, *Presumed
Portrait of Giovanni
Bellini,* c.1510,
Statens Museum for
Kunst, Copenhagen.

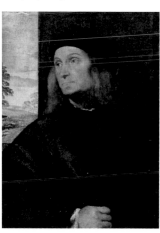

radical position. He led the
bloody Anabaptist revolt which
was condemned by Dürer, p. 114.

Pacioli, Luca (Borgo San
Sepolcro 1445–Rome 1517), friar
and mathematician. He wrote
several treatises, including
De Divina Proportione, a
fundamental text in the
study of perspective
undertaken by Dürer and
many of his contemporary
fellow artists, pp. 46, 47.

Paumgartner, wealthy
Nuremberg family who
commissioned works from
Dürer, pp. 40, 41.

Pirckheimer, Willibald,
Nuremberg humanist, and a
very close friend to Dürer,
pp. 49, 74, 87, 116, 130.

Pontormo, real name Jacopo
Carrucci (Pontormo, Empoli
1494–Florence 1550), early
Mannerist painter. He was a
pupil of Leonardo and Piero
di Cosimo. He greatly admired
Dürer's work, often in opposition
to the Florentine environment in
which he was working, p. 110.

Schongauer Martin
(Colmar 1453–Breisach 1491),
German painter and engraver. He
influenced the figurative culture
of his time. His engravings were
well-known throughout Europe,
were imitated in many workshops,
and proved fundamental to the
young Dürer, pp. 16, 17, 177.

Stoss, Veit (Nuremberg
1445–c.1533), multitalented
artist and a contemporary of
Dürer. He produced famous
wooden sculptures, worked
also in marble, and executed
splendid engravings and
paintings, pp. 36, 37.

Titian, real name Tiziano
Vecellio (Pieve di Cadore
1490–Venice 1576), one of the
greatest painters of the 16th-
century Venetian School. He
painted the frescos for the
Fondaco dei Tedeschi with
Giorgione, which Dürer
admired, pp. 44, 48, 129.

Wolgemut, Michael
(Nuremberg 1434–1518),
painter, carver, engraver.
Dürer was apprenticed in
his workshop, pp. 12, 16.

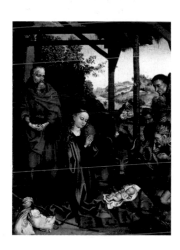

■ Martin Schongauer,
*Adoration of the
Shepherds,* c.1472,
Staatliche Museen, Berlin.

A DK PUBLISHING BOOK
Visit us on the World Wide Web at http://www.dk.com

TRANSLATOR
Anna Bennett

DESIGN ASSISTANCE
Joanne Mitchell

MANAGING EDITOR
Anna Kruger

Series of monographs
edited by Stefano Peccatori and Stefano Zuffi

Text by Stefano Zuffi

PICTURE SOURCES
Archivio Electa
Elemond Editori Associati wishes to thank all those museums and
photographic libraries who have kindly supplied pictures, and would be pleased
to hear from copyright holders in the event of uncredited picture sources.

Project created in conjunction with
La Biblioteca editrice s.r.l., Milan

First published in the United States in 1999 by DK Publishing Inc.
95 Madison Avenue, New York, New York 10016

ISBN 0-7894-4137-3

Library of Congress Catalog Card Number: 98-86751

First published in Great Britain in 1999
by Dorling Kindersley Limited,
9 Henrietta Street, London WC2E 8PS

A CIP catalogue record of this book is available from the British Library.

ISBN 0751307263

2 4 6 8 10 9 7 5 3 1

Printed by Elemond s.p.a. at Martellago (Venice)